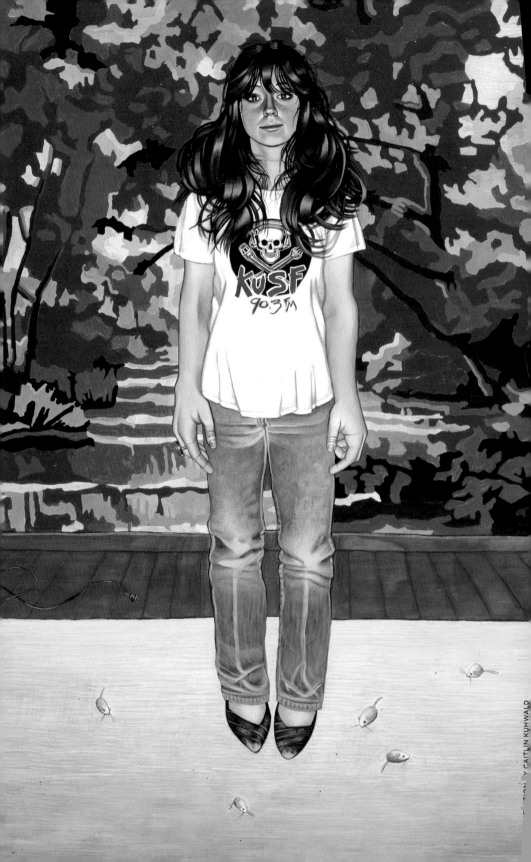

№4

THREE BY THREE ILLUSTRATION ANNUAL

Sponsored by 3x3 Magazine

PUBLISHED IN 2008 BY

3X3 MAGAZINE : 244 FIFTH AVENUE : SUITE F269 : NEW YORK NEW YORK 10001

PROFESSIONAL SHOW JUDGES

Kit Hinrichs **PENTAGRAM**

Edel Rodriguez **TIME MAGAZINE**

Kayoko Suzuki-Lange **ART DIRECTOR**

Paul Hodgson **DESIGN DIRECTOR, CUNDARI**

Jeremy Lacroix **WIRED MAGAZINE**

Olaf Hajek **ILLUSTRATOR, GERMANY**

Kenneth Andersson **ILLUSTRATOR, SWEDEN**

CHILDREN'S BOOK SHOW JUDGES

Christiane Germain **L'ECOLE DES LOISIRS, FRANCE**

Paula Wiseman **SIMON & SCHUSTER BOOKS FOR YOUNG READERS**

Sara Reynolds **DUTTON CHILDREN'S BOOKS**

Guido Pigni **ILLUSTRATOR, ITALY**

Adam McCauley **ILLUSTRATOR**

Jaime Zollars **ILLUSTRATOR**

ANIMATION SHOW JUDGES

Mario Cavalli **ANIMATOR, UNITED KINGDOM**

Run Wrake **ANIMATOR, UNITED KINGDOM**

Oscar Grillo **ANIMATOR, UNITED KINGDOM**

Eric Goldberg **ANIMATOR**

STUDENT SHOW JUDGES

Noah Woods **ART CENTER COLLEGE OF DESIGN**

Melanie Reim **FASHION INSTITUTE OF TECHNOLOGY**

Whitney Sherman **MARYLAND INSTITUTE COLLEGE OF ART**

Alex Murawski **UNIVERSITY OF GEORGIA**

Ian Murray **STOCKPORT COLLEGE, UNITED KINGDOM**

Lucy Scherer **THE ART WORKS, UNITED KINGDOM**

No4

THREE BY THREE ILLUSTRATION ANNUAL

Sponsored by 3x3 Magazine

HONORING
Joe Morse
ILLUSTRATOR: EDUCATOR OF THE YEAR

PUBLISHER + DESIGN DIRECTOR
Charles Hively

ART DIRECTOR + DESIGNER
Sarah Munt

COPY EDITOR
Kate Lane

INTERNS
Laura Baker
Adam S. Doyle
Justin Gabbard
Jessica Quinones
Matt Rota

COVER ILLUSTRATION BY
Jay Vollmar

PRINTED IN CANADA BY
Westcan Printing Group

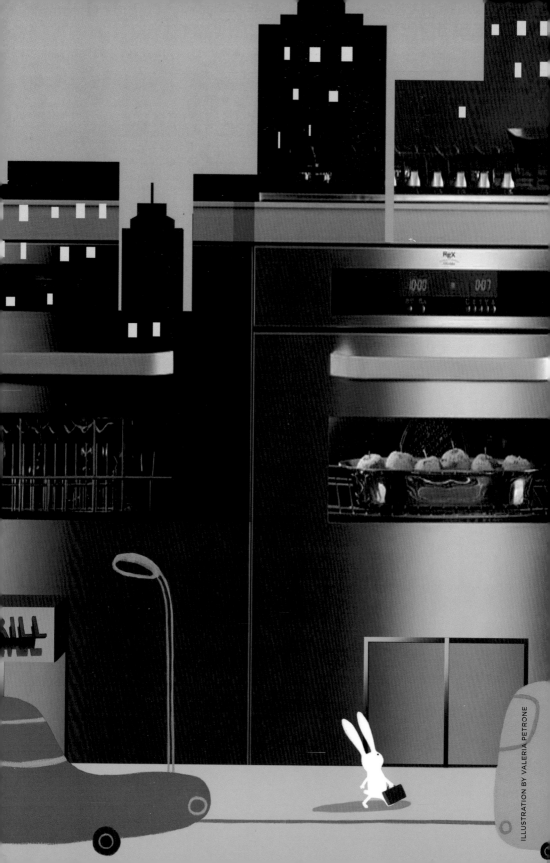

CONTENTS

EACH YEAR WE HAVE THE PLEASURE OF SEEING SOME OF THE BEST ILLUSTRATION BEING DONE TODAY COME THROUGH OUR DOORS AND EACH YEAR OUR DISTINGUISHED PANEL OF JUDGES ZEROES IN ON THE BEST OF THE BEST. THIS YEAR WAS NO EXCEPTION, A YEAR WHEN WE SAW A THIRTY-PERCENT INCREASE IN THE TOTAL NUMBER OF ENTRIES. COUPLED WITH THE ADDITION OF TWO NEW CATEGORIES, ANIMATION AND GALLERY, OUR JUDGES HAD THEIR HANDS FULL JUDGING NEARLY 3,000 PIECES. BUT AS ALWAYS THE CREAM ROSE TO THE TOP AND WITH THAT WE ARE PROUD TO PRESENT OUR LARGEST ANNUAL TO DATE WITH OVER 400 WINNERS, A TIME CAPSULE OF THE BEST ILLUSTRATION BEING DONE TODAY BY THE PROFESSIONAL AND STUDENT ILLUSTRATION COMMUNITY WORLDWIDE. OF SPECIAL NOTE THIS YEAR GERMANY TOPPED OUR STUDENT SHOW WITH THE MOST SINGLE WINNERS AND OUR CHILDREN'S BOOK SHOW SAW MORE ENTRIES FROM OUTSIDE NORTH AMERICA THAN EVER BEFORE MAKING 3X3 A TRULY INTERNATIONAL ILLUSTRATION SHOW. SO SIT BACK, TURN THE PAGE AND START DROOLING! —THE PUBLISHER

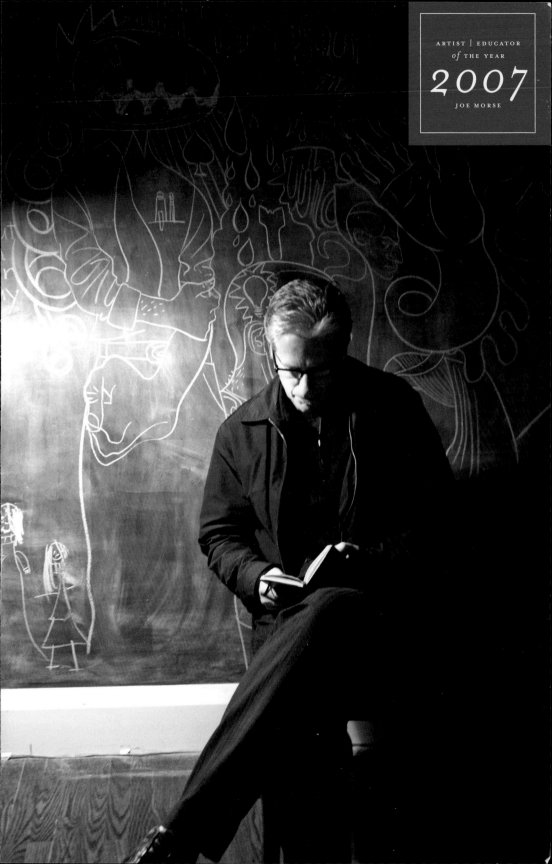

JOE MORSE *didn't start out to be an illustrator, printmaking was his love; now he's an international image-maker. A happy convert to illustration he considers himself first and foremost a draughtsman. As a visual problem solver he also loves the process of completing his assignments even though they involve working with highly volatile materials outside, even in the dead of a Canadian winter. His work is just that toxic, but the result is anything but. Capturing a likeness of celebrities, political figures and everyday icons Joe echoes the human spirit in his work. A devoted family man, a prolific illustrator, a dedicated teacher and chair of the illustration department at Sheridan outside Toronto one often wonders how he manages to pack all his responsibilities in a 24-hour day. We're just glad he does and are pleased to honor him here as our 3x3 Educator/Illustrator of the year, 2007.*

Q Tell us about your early schooling. Do you come from an artistic family? Did you always want to be an artist?

A I grew up the youngest of seven kids in Windsor, Ontario, across the river from Detroit. My family was hockey obsessed and I spent most of my youth trying to avoid being killed by my sports-crazed brothers. Art seemed to be the only territory they hadn't already staked out.

Q What were some of your early influences? Other artists you admired? Who do you admire today?

A Comic books, *Mad Magazine* and album cover art (yes, there used to be these vinyl things called records...) influenced the drawings in every schoolbook I ever owned. In art school it was the German expressionists, Max Beckmann.... During my postgraduate stay in Florence I was into Jean-Charles Blais, Anselm Kiefer and Alfred Hrdlicka. I was recently introduced to the photographic work of Hans-Peter Feldmann. He has a series that spanned 20 years and is nothing but photographs of car radios—every time he heard a song he liked he photographed the car radio, creating poetry from the banal.

Q You studied fine arts and printmaking at the Ontario College of Art in Toronto. How has printmaking influenced your work?

A Printmaking was and is fundamental to my work, even though my last print was executed 20 years ago. The engagement with process, the multiple images and the incredible variety of approaches seems to parallel how I use the computer today. But, more importantly, print taught me to trust the uncontrolled—the magic of material interacting with surface. Each time I paint with oil and I allow the solvent to bite into and obliterate image I am returning to the printshop.

Q When did the break come between being a fine artist and an illustrator? How did that transition come about?

A I spent seven years after graduation working as a hyphenated artist-illustrator. During the first Gulf War, I vented my outrage in a series of fists painted in black ink. The approach I use today came out of this maelstrom. It soon became apparent that the split personality had to go. I packed up the illustrator and the artist and followed this new path—making images that meant something to me but also could solve visual problems.

Q What were your early impressions of illustration? Were there any particular artists who influenced your decision to become an illustrator?

A I remember my first portfolio review. My work was larger than the art director's office. I showed him lithographs, done in a medium I was no longer working in. It took me a year to get my first spot illustration. As far as influence, the work of Blair Drawson is vivid in my memory. He seemed to be blazing a path that allowed an artist to make illustration.

Q How did you get your first big break?

A I submitted some of my personal paintings

to *American Illustration 13* and two pieces were selected. The week that the book launched I was commissioned to do a review page for *Rolling Stone*—my first US job. Later, the same book would make its way into the hands of Erik Kessels of KesselsKramer in Amsterdam and his Nike Europe assignment would help launch my sports imagery.

Q How has your work progressed, and how is today's work different than what you produced when you were first starting out?

A My work has not so much "progressed" as changed with my needs and the needs of the marketplace. Everything has changed since I started. The entire work cycle has been transformed. But what remains the same is the integrity and passion you must renew in each commission.

Q Talk a bit about your process. What types of sketches do you provide the art director?

A I work in ballpoint pen on paper, then I scan those sketches into Photoshop. My roughs, which I show, are quite finished linears that I use to trace for the final painting.

Q What part does digital play in developing the final piece?

A The development of the rough stage is my R&D. I then use the computer as a tool to push the image I've created by hand. Sometimes a rough is pushed through my hand-computer loop multiple times. The final sketch then goes to oil paint first, then acrylic and finally the scanner glass.

Q You've mentioned having to work outdoors

with your work. What kind of materials are you using?

A Bad stuff and I am very careful. I wear a gas mask and studio clothes and shower after painting. I work fast in oil and I don't worry over my choices—I feel one of the strengths of the work is it's immediacy.

Q Are you working in any other medium?

A Other than my alter ego work, which is fully digital, I do not work in other media.

Q Where do you see your work progressing? What do you see as the value of creating an alter ego?

A I think you should try to look up from your drawing board periodically. I have numerous ideas in various stages on my desk, and I think it's most likely that I'll expand my work towards developing more of my own content and motion.

The alter ego evolved from my day job as a professor. I found that, in the classroom, I would use a particular visual approach to record notes and to generate course materials. These visual diagrams seemed to take on their own personality, so I attached a persona to them. I created this other artist because he worked so differently from me.

Q Any thoughts about the current state of illustration?

A It is always hard to ask an illustrator to look at the landscape because, deadlines being what they are, you're usually focused on the road you are traveling on. But I think that illustration has been completely remade in the last five years. The title "illustrator" is a poor descriptor to express the overwhelming variety of roles that now exist in almost every area of visual communications. Today, it is incredibly difficult to break into illustration using the old paradigm of portfolio visit and promos. Illustrators need to create content, develop new approaches, pitch projects and collaborate with other creatives.

Q Do you feel there is anything missing in today's education of an illustrator?

A Probably illustration itself. I mean, we load in character design, concept design for games, artist exhibition skills, business knowledge… the biggest challenge is to balance new skill

sets with the traditional read/think/draw of the job. At the core you need to have something that you can do that others can't, and thinking visually then making a picture is something we illustrator types could always claim as our own. Even if, because of the many new roles our grads can take on, we come up with another title for what we do, I still believe we need to teach the nuts and bolts of solving visual problems.

At Sheridan, to meet the changing demands of the marketplace, we have moved our curricula to include business/marketing skills, advanced digital skills and working in collaborative teams. We also purposely moved to a four-year bachelor's degree from a three-year diploma because we wanted our students to benefit from the breadth of bachelor's degree studies.

Q Let's talk about your experiences as a teacher. What do you feel is an instructor's role?

A I believe there is a fundamental responsibility commensurate with the role that goes missing if you take a "missionary" approach. You cannot go into the teaching environment believing you have nothing to learn. The most effective and passionate teachers are alive to the learning possibilities that they contribute to, rather than control.

I think your role changes as the students near graduation, but I firmly believe that at no time do I teach style (especially style thievery). Rather, through sweat and work, artists reveal their personal voice. Another advantage of teaching is that I have grads from the past seventeen years that I receive information about and from.

Q How does your work as a department chair differ from your work as a teacher?

A I still teach courses as well as direct the program, and it is interesting how different the two roles are. The difference between teaching and administrative tasks is obvious, but there is also a responsibility to leadership, student expectation and program profile that were not my concerns as a teaching faculty (in the studio, you are just not that aware of the institutional context). We graduated our first cohort in the four-year bachelor of applied arts illustration program this year. It was an incredible experience to be part of designing/building/implementing a degree while finishing a diploma program and launching a two-year bridging diploma/degree process. I learned how to deal with immediate issues without losing focus on the long-term vision and goals.

Q What do you look for when hiring a new instructor?

A Great work helps, to start with, but that has to be balanced with a track record of working with other people within an organization—teaching or art direction. Our teaching environment is collaborative and critically based on a group dynamic where each person brings very different strengths to the table. If you are looking to move forward, you need to find people that bring energy and passion to everything they do.

Q What is your advice to graduates entering the field today?

A You have to be able to hold two very contradictory thoughts in your head at once. First, there is nothing waiting for you when you leave school. There is no one standing with open arms. No room is being made for you within the ranks. Why!! Because the world doesn't know it needs you yet. Second, you have all the freedom in the world. You can do anything and achieve whatever you want to achieve. If you build ideas with integrity and excellence, clients will follow. Nothing is immutable—you can reinvent the world. Hopefully, the first thought will help you to not feel personally cheated or discouraged. It isn't about you; it's just a fact. The second thought is all about you and what you do. Illustration is a business of personal relationships—so be nice, and merit. And be good.

Q Any final words to teachers?

A In a world of hybridization, we can be swallowed by animation, entertainment design or graphic design—or we can carve out a definition for illustration that recognizes how important we are to visual culture. Where is our definitive history of illustration? Where is our scholarship placing us in an important cultural context? Where are the museum exhibitions that cement our role in society? The future of illustration is in the hands of educators. We need to talk with each other and support each other and our grads. It is only in the schools teaching illustration that there is a shared experience from which we can forge some long lasting connections to build the profession. ∎

1 **ART DIRECTOR**
Mark Murphy
ILLUSTRATOR
Chris Buzelli
DESIGN AGENCY
Murphy Design
CLIENT
Serbin Communications

2 **ART DIRECTOR**
Piper Smith
DESIGNER
George Zipparo
ILLUSTRATOR
Douglas Fraser
CLIENT
Lindgren & Smith Inc.

2

1

1

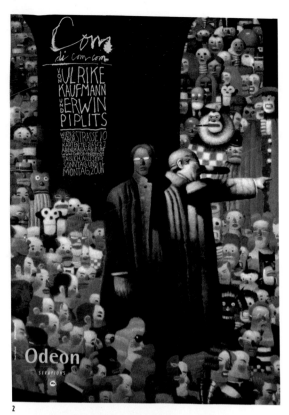

2

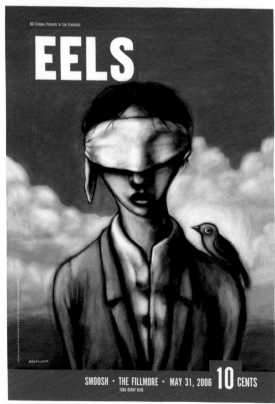

3

1 ART DIRECTOR:
Carrie Evans
ILLUSTRATOR:
Sharon Tancredi
DESIGN AGENCY:
R&R Partners Inc.
CLIENT:
*R&R All-Suite Hotel &
Casino, Las Vegas*

2 ART DIRECTOR:
Erwin Piplits
DESIGNER:
Brad Holland
ILLUSTRATOR:
Brad Holland
CLIENT:
*Odeon/Serapions
Theater*

3 ART DIRECTOR:
Tom Scott
DESIGNER:
John Mavroudis
ILLUSTRATOR:
John Mavroudis
DESIGN AGENCY:
ZenPop.com
CLIENT:
Bill Graham Presents

ILLUSTRATOR:
Valeria Petrone
CLIENT:
Abitare

1 DESIGNER:
Bill Henderson
ILLUSTRATOR:
Craig Frazier
DESIGN AGENCY:
Form & Content UK
CLIENT:
Ciana Ltd.

2-3 ART DIRECTOR:
Todd McCracken
DESIGNER:
Nigel Buchanan
ILLUSTRATOR:
Nigel Buchanan
DESIGN AGENCY:
Grey World Wide
CLIENT:
Grey World Wide

1 ART DIRECTOR:
Sophie Escalmel
ILLUSTRATOR:
Nate Williams
DESIGN AGENCY:
Anatome
CLIENT:
Conseil General du Val-de-Marne

BRONZE

2 ART DIRECTOR:
Jay Vollmar
ILLUSTRATOR:
Jay Vollmar
CLIENT:
Fox Theatre Boulder

2

1

ART DIRECTOR:
Rob Abeyta
CREATIVE DIRECTO
John Boiler
ILLUSTRATOR:
Yuko Shimizu
DESIGN AGENCY:
72andSunny
CLIENT:
Microsoft

SILVER

ART DIRECTOR:
Chie Araki
ILLUSTRATOR:
Yuko Shimizu
CLIENT:
MTV

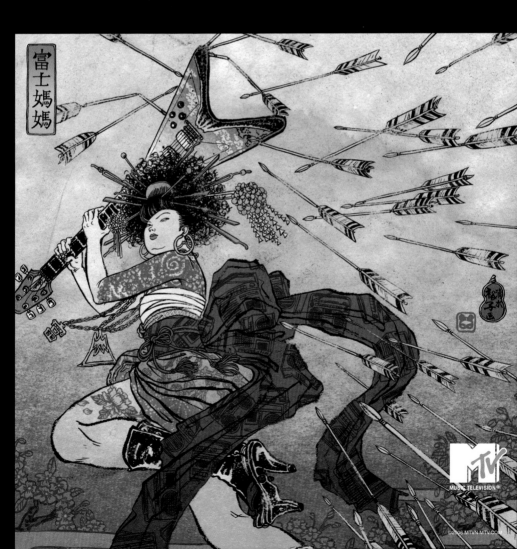

Titanium Design
CLIENT:
IKRAM

2 **DESIGNER**:
Cia Kilander
ILLUSTRATOR:
Lasse Skarbovik
CLIENT:
Fastighetstidningen

3 **DESIGNER**:
Lynn Brofsky
ILLUSTRATOR:
Lasse Skarbovik
DESIGN AGENCY:
Marlena Agency
CLIENT:
Marlena Agency

1 **ART DIRECTOR:**
Colleen Teitgen
ILLUSTRATOR:
Caitlin Kuhwald
DESIGN AGENCY:
Eric Kent Wine Cellars
CLIENT:
Eric Kent Wines

2 **ART DIRECTOR:**
Jared Weinstein
ILLUSTRATOR:
Phil Wheeler
DESIGN AGENCY:
Ogilvy Worldwide
CLIENT:
IBM

1 ART DIRECTOR:
Danielle Canonico
ILLUSTRATOR:
Michael Gibbs
CLIENT:
Virginia Opera

2 ILLUSTRATOR:
Rachel Salomon

1 **ART DIRECTOR:**
Yutaka Narui
DESIGNER:
Yoshinori Hineno
ILLUSTRATOR:
Tatsuro Kiuchi
DESIGN AGENCY:
Hineno Design
CLIENT:
Nevula Project

2 **ART DIRECTOR:**
David Sterling,
Mark Randall
ILLUSTRATOR:
Charles Wilkin
DESIGN AGENCY:
Worldstudio Inc.
CLIENT:
Times Square Alliance/
AIGA

3 **ART DIRECTOR:**
Nicky Southin
ILLUSTRATOR:
Jan Bowman
CLIENT:
Newington Green Action
Group

2

3

ART DIRECTOR:
Giorgio Camuffo
ILLUSTRATOR:
John Hersey
DESIGN AGENCY:
Studio Camuffo
CLIENT:
Apria Motorcycles

Bald fand sich zu ihr im Grünen // dort ein Jüngling ein.

Linchen war ein gutes Mädchen // war schön jung und treu,

Schön und niedlich war der Bube // war wie ein Birken schlank.

»Gib mir doch ein einzigs Küßchen // liebes Linchen, her!«

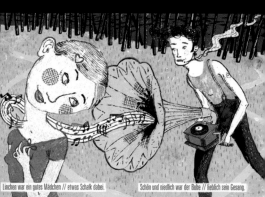

Linchen war ein gutes Mädchen // etwas Schalk dabei.

Schön und niedlich war der Bube // lieblich sein Gesang.

Hierauf reicht sie ihm ein Küßchen // und noch etwas mehr.

PUBLISHER
Werkstat der HAW
Hamburg

Linchen ging einmal spazieren // in den Fichtenhain;

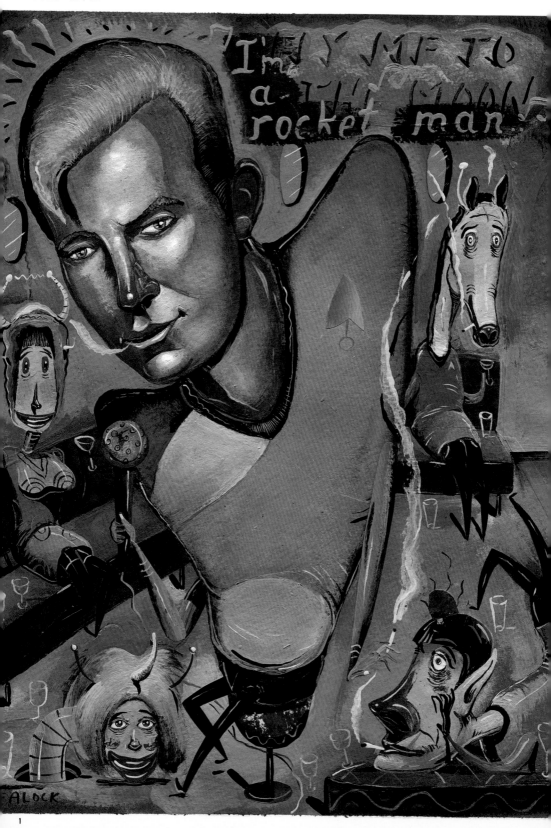

2

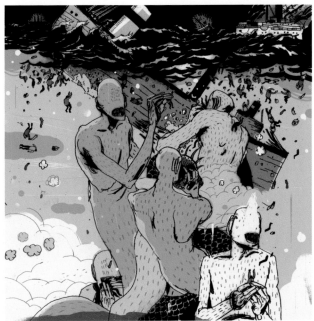

3

1 ART DIRECTOR:
Janine Vangool
ILLUSTRATOR:
Rick Sealock
DESIGN AGENCY:
*Vangool Design &
Typography*
PUBLISHER:
Uppercase Gallery

2 ART DIRECTOR:
Beth Potter
ILLUSTRATOR:
John Hendrix
PUBLISHER:
Farrar Strauss & Giroux

3 ART DIRECTOR:
Jacob Covey
ILLUSTRATOR:
Josh Cochran
DESIGN AGENCY:
Fantagraphics
PUBLISHER:
Fantagraphics

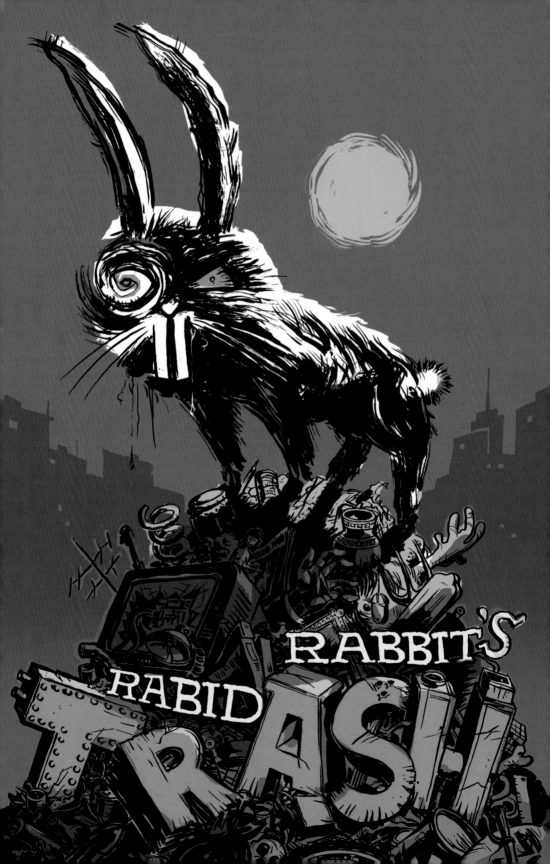

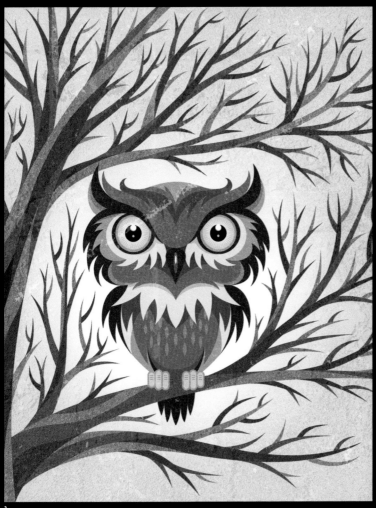

2

3

1 **ART DIRECTOR**
Paul Hoppe
ILLUSTRATOR
Paul Hoppe
PUBLISHER
Rabid Rabbit

2 **ART DIRECTOR**
Von Glitschka
ILLUSTRATOR
Von Glitschka
DESIGN AGENCY
Glitschka Studios
PUBLISHER
FTW Publishing

3 **ART DIRECTOR**
Paul Buckley
ILLUSTRATOR
Mick Wiggins
PUBLISHER
Penguin Books

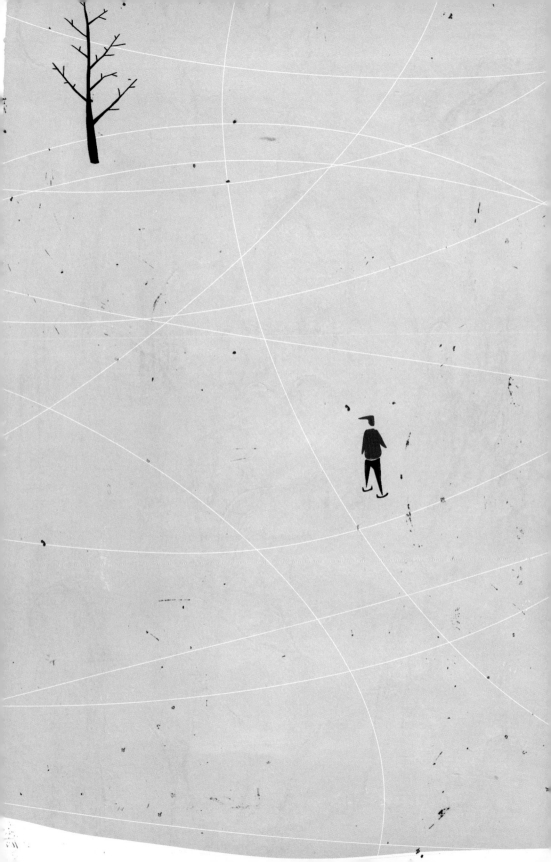

1 ART DIRECTOR:
Riccardo Falcinelli
ILLUSTRATOR:
Shout
PUBLISHER:
Minimum Fax

BRONZE

2 ART DIRECTOR:
Riccardo Falcinelli
ILLUSTRATOR:
Shout
PUBLISHER:
Minimum Fax

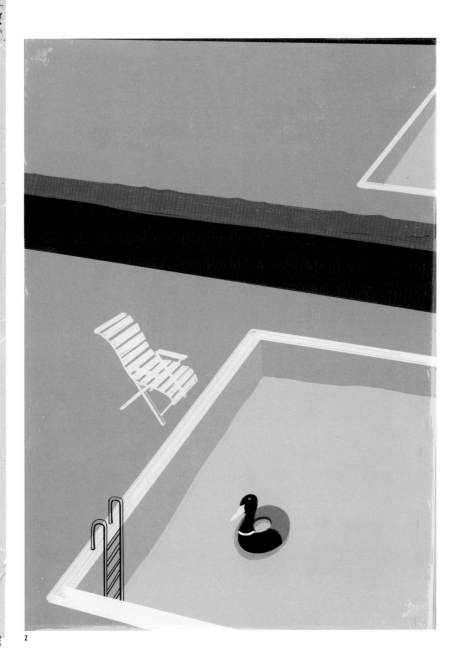

1

1 ART DIRECTOR:
Andrew Hoyem
ILLUSTRATOR:
Mark Ulriksen
PUBLISHER:
Arion Press

2 ART DIRECTOR:
Mark Heflin
ILLUSTRATOR:
Mark Ulriksen
PUBLISHER:
American Illustration

2

1

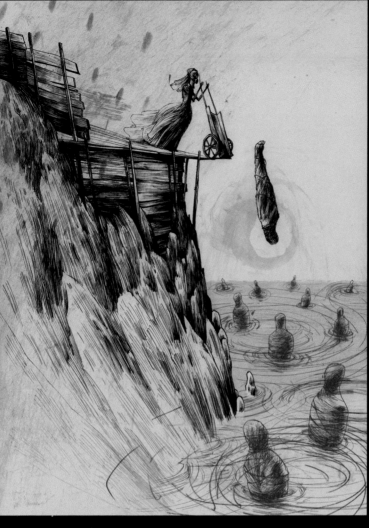

1　**ART DIRECTOR**
Angus Hyland
EDITOR
Angus Hyland
ILLUSTRATOR
Yuko Shimizu
DESIGN AGENC
Pentagram
PUBLISHER
*Pentagram and
Laurence King
Publishing*

2　**ART DIRECTOR**
*Steve Adams,
Simon Fortin*
ILLUSTRATOR
Steve Adams
PUBLISHER
Illustration Quebe

3　**ART DIRECTOR**
Hendrik Hellige
ILLUSTRATOR
Lars Henkel
DESIGN AGENC
Reflektorium
PUBLISHER
Die Gestalten Verle

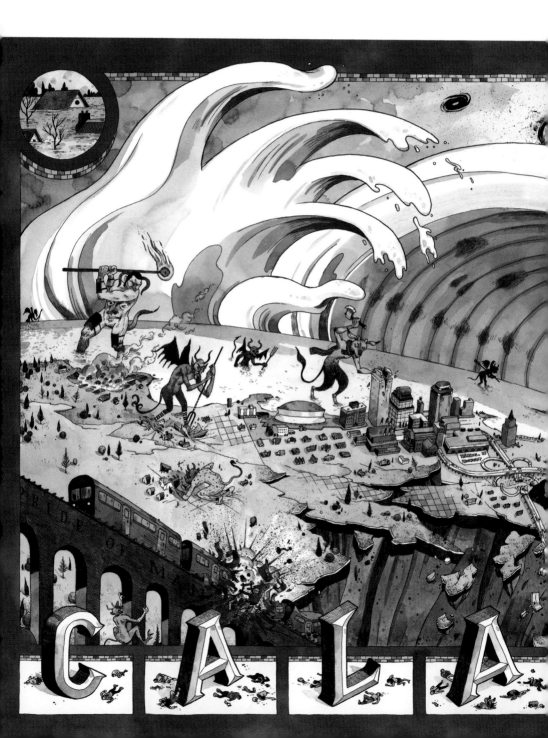

ART DIRECTOR:
Mark Heflin
ILLUSTRATOR:
John Hendrix
PUBLISHER:
American Illustration

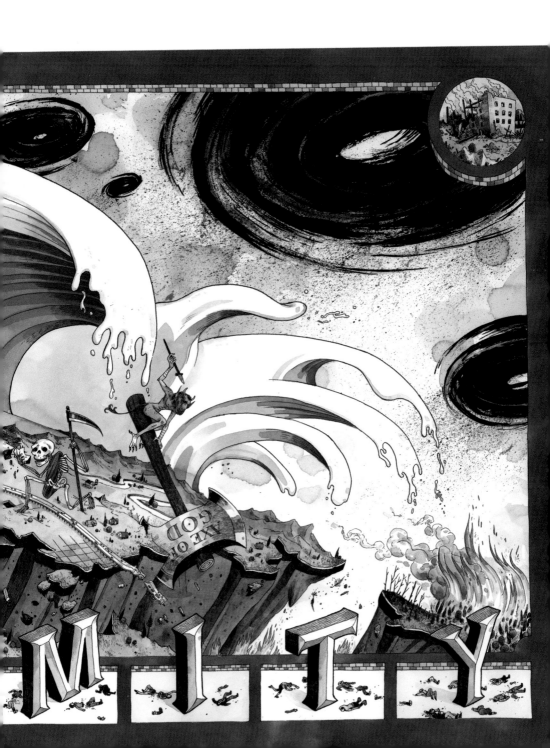

GRAPHIC ARTISTS GUILD'S

DIRECTORY of ILLUSTRATION

23

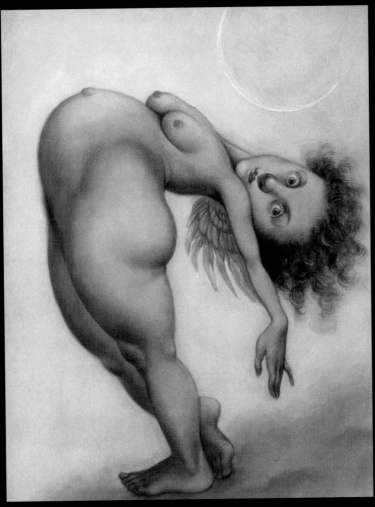

1 **ART DIRECTOR** :
Mark Murphy
ILLUSTRATOR :
Kristian Olson
DESIGN AGENCY :
Murphy Design
PUBLISHER :
Serbin Communications/
Graphic Artist's Guild

2 **ART DIRECTOR** :
Anita Kunz
DESIGNER :
Dick Chin
ILLUSTRATOR :
Anita Kunz
PUBLISHER :
Ken Steacy Publishing

2

1

2

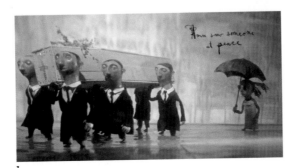

1 ART DIRECTOR:
Jasmine Lee
ILLUSTRATOR:
Brad Holland
PUBLISHER:
Penguin Books

2 ART DIRECTOR:
Armin Abmeier
ILLUSTRATOR:
Max
DESIGN AGENCY:
Die Tollen Hefte
PUBLISHER:
Buchergilde Gutenberg

3 ILLUSTRATOR:
Red Nose Studio
PUBLISHER:
F+W Publications

1 EDITOR:
Gavin Morris
ILLUSTRATOR:
Sara Fanelli
PUBLISHER:
Transworld

2 ART DIRECTOR:
Joann Hill
ILLUSTRATOR:
Istvan Banyai
PUBLISHER:
Clarion Books

3 ART DIRECTOR:
J-F Saada
DESIGNER:
F. Maurel
ILLUSTRATOR:
Pascal Lemaître
PUBLISHER:
Editions Nathan

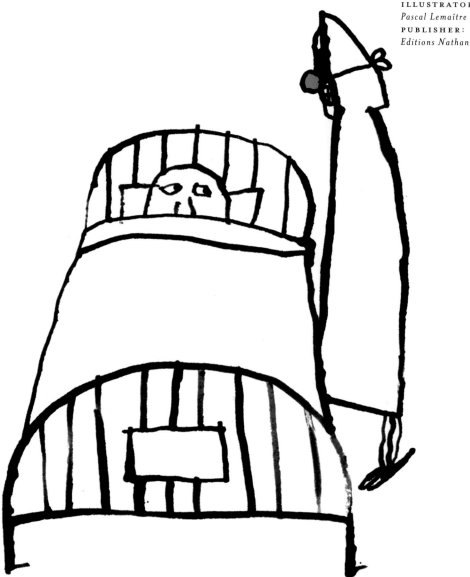

1

2

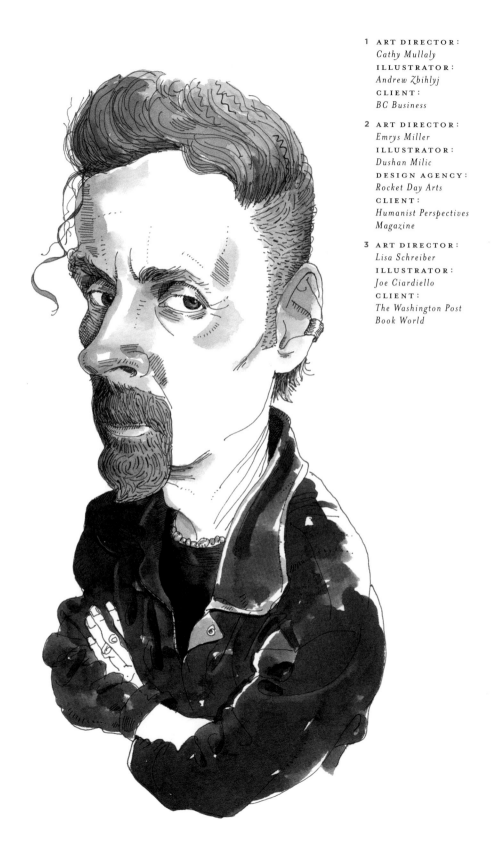

1 ART DIRECTOR:
Cathy Mullaly
ILLUSTRATOR:
Andrew Zbihlyj
CLIENT:
BC Business

2 ART DIRECTOR:
Emrys Miller
ILLUSTRATOR:
Dushan Milic
DESIGN AGENCY:
Rocket Day Arts
CLIENT:
*Humanist Perspectives
Magazine*

3 ART DIRECTOR:
Lisa Schreiber
ILLUSTRATOR:
Joe Ciardiello
CLIENT:
*The Washington Post
Book World*

1 **ART DIRECTOR**:
Gloria Ghisi
ILLUSTRATOR:
Emiliano Ponzi
CLIENT:
Lo Donna Magazine

2 **ART DIRECTOR**:
Graham Berridge
ILLUSTRATOR:
Michelle Thompson
CLIENT:
Wanderlust Magazine

1 2

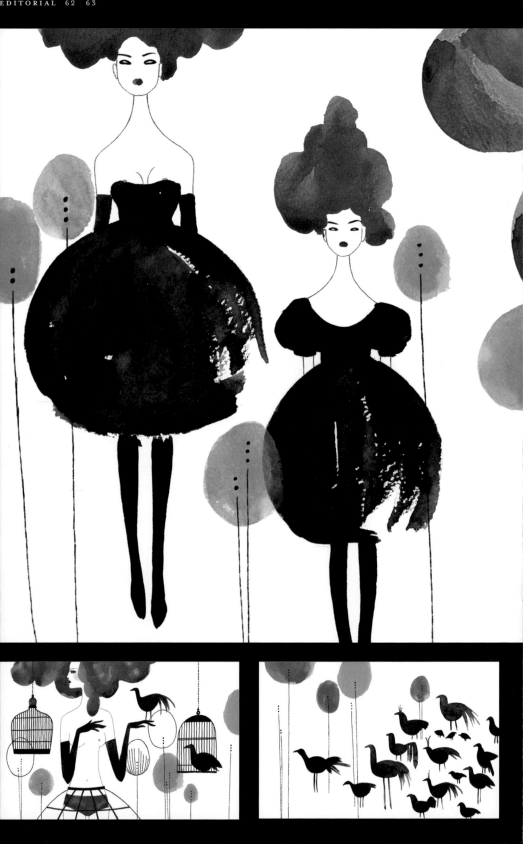

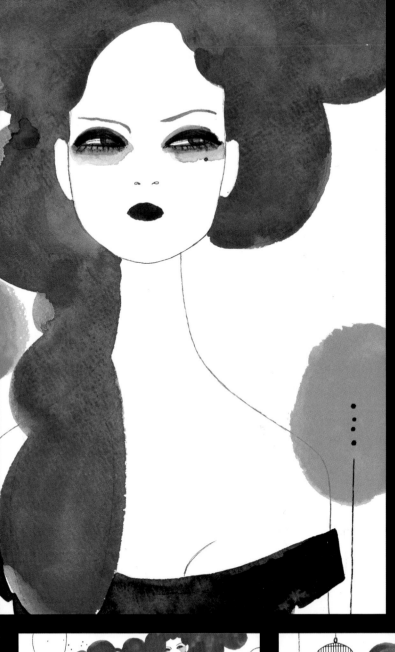

Anita Mrusek
ILLUSTRATOR :
Anja Kroencke
CLIENT :
Squint Magazine

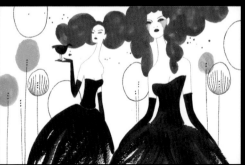

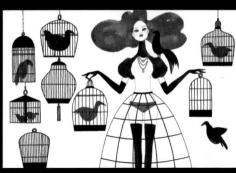

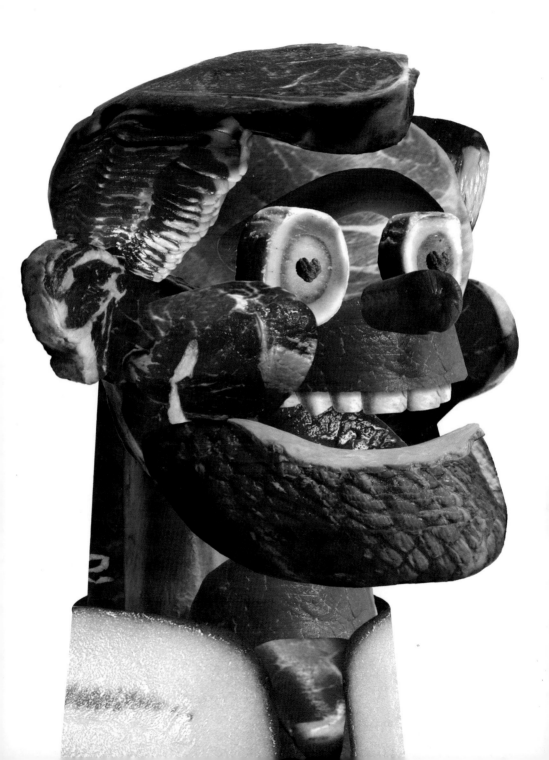

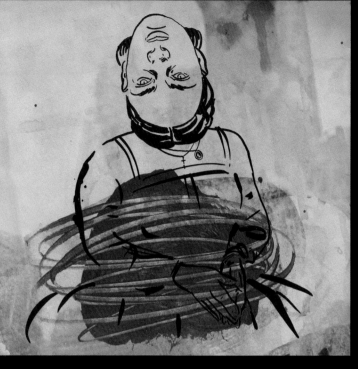

1 **ART DIRECTOR**
Timothy Leong
ILLUSTRATOR
Eddie Guy
CLIENT
Men's Health

2 **ART DIRECTOR**
Carol Kaufman
ILLUSTRATOR
Ward Schumaker
CLIENT
Los Angeles Times B
Review

3 **ART DIRECTOR**
Tom Brown
ILLUSTRATOR
Evonrude
CLIENT
MoneySense Magazi

1 PICTURE EDITOR:
Paul Davis
ILLUSTRATOR:
Jeffrey Fisher
CLIENT:
The Drawbridge

2 ART DIRECTOR:
SooJin Buzelli
ILLUSTRATOR:
Yuko Shimizu
CLIENT:
*Global Custodian
Magazine*

硫黄島からの手紙

クリント・イーストウッド監督

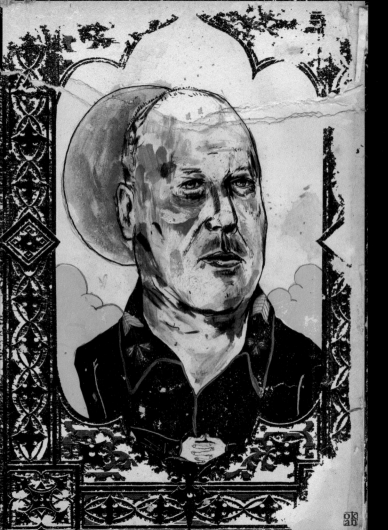

Ekin Seker
DESIGNER:
Umit Kurt
ILLUSTRATOR:
Okan Arabacioglu
CLIENT:
Bant Magazine

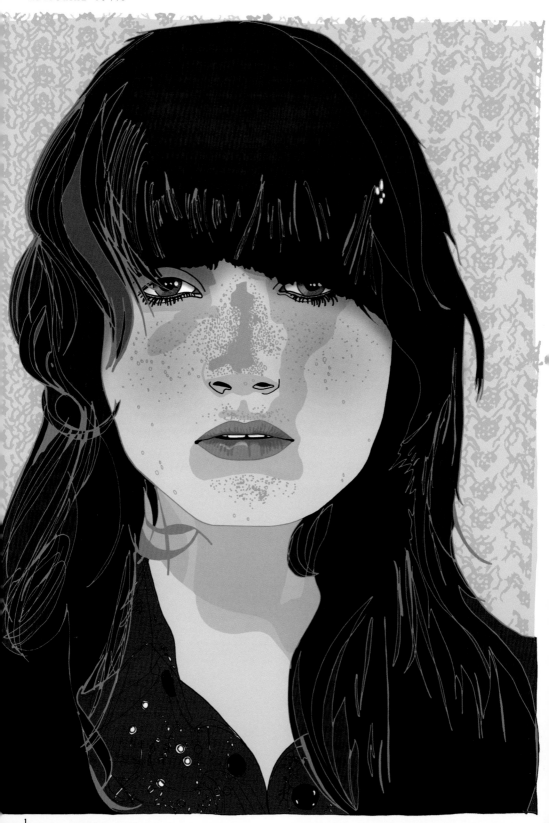

ART DIRECTOR:
Amelie Schneider
ILLUSTRATOR:
Anne Lueck
CLIENT:
Jungsheft Magazine

2 **ART DIRECTOR**:
Nicholas Blechman
ILLUSTRATOR:
Istvan Banyai
CLIENT:
*The New York Times
Book Review*

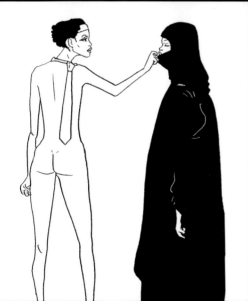

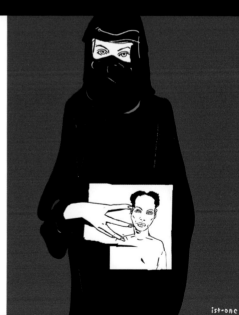

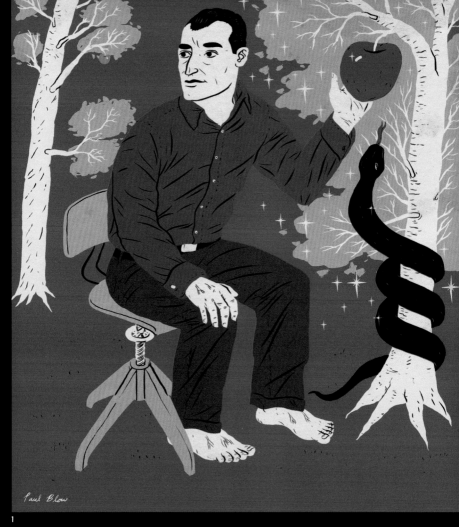

1

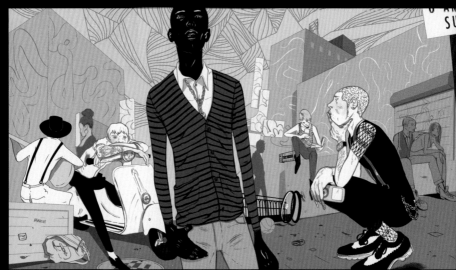

1 **ART DIRECTOR:**
Ivan Cottrell
ILLUSTRATOR:
Paul Blow
CLIENT:
Design Week

2 **ART DIRECTOR:**
Sean Bumgarner
ILLUSTRATOR:
Marcos Chin
CLIENT:
Complex Magazine

3-4 **ART DIRECTOR:**
Tadahiko Kataoka
ILLUSTRATOR:
Tatsuro Kiuchi
CLIENT:
Kadokawa Shoten

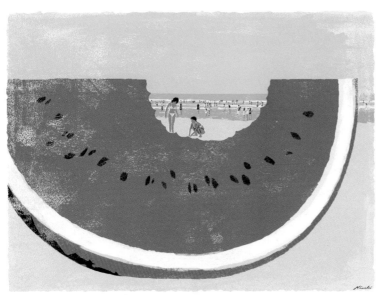

3

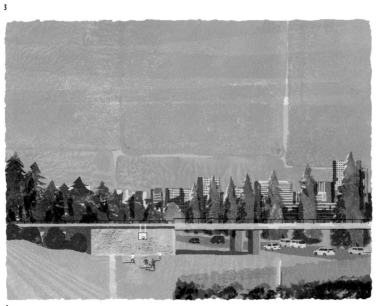

4

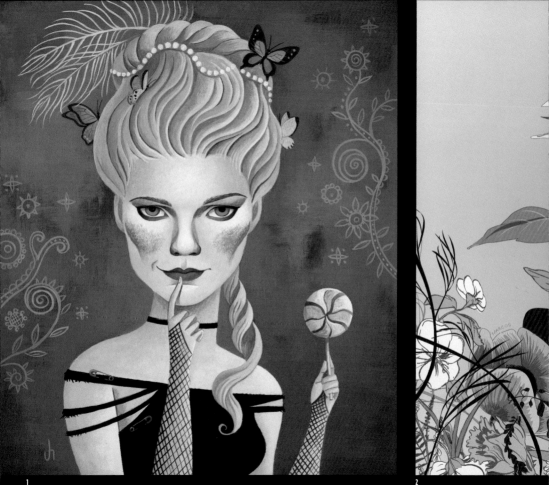

2 ART DIRECTOR:
SooJin Buzelli
ILLUSTRATOR:
Marcos Chin
CLIENT:
Plan Sponsor Magazine

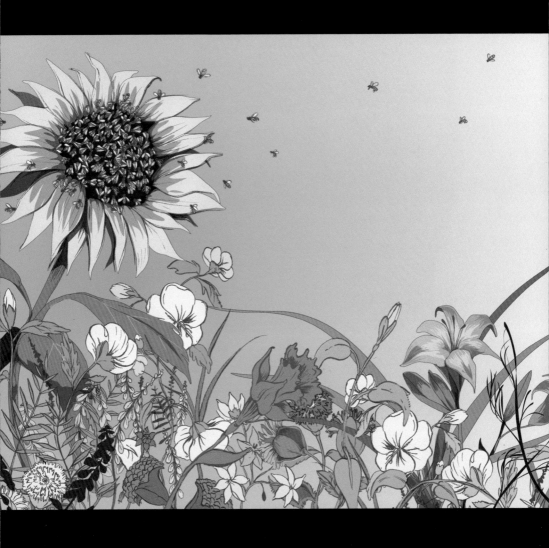

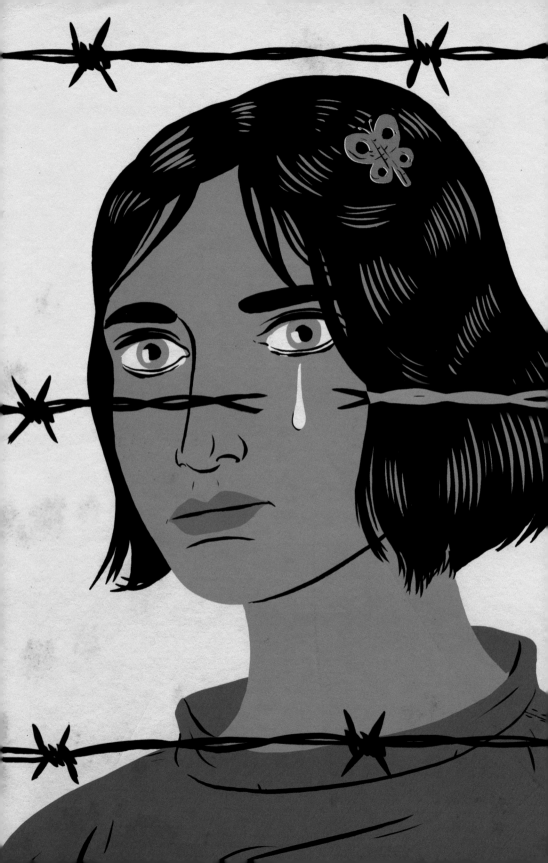

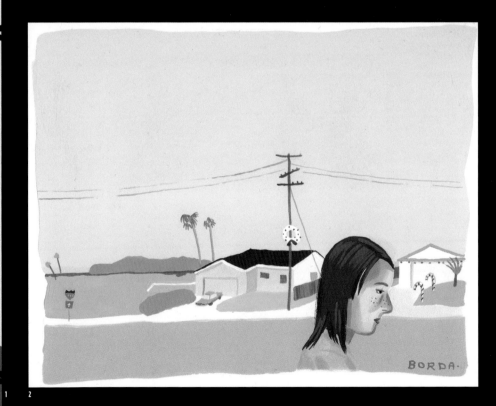

1 2

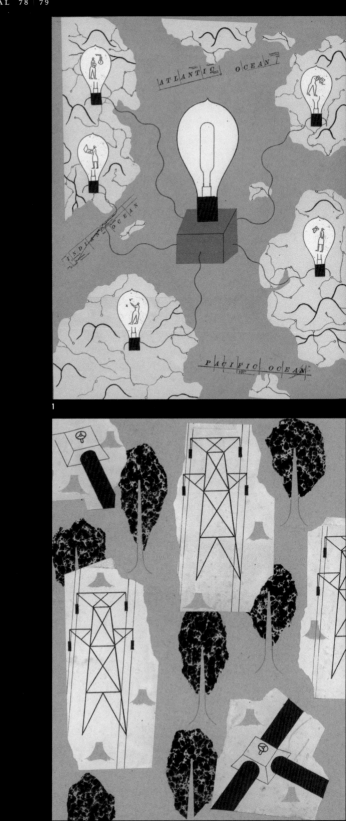

1

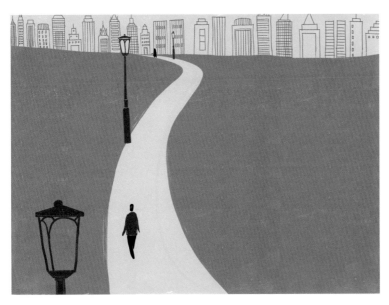

1 **DESIGNER:**
Jessie Clear
ILLUSTRATOR:
Philippe Weisbecker
DESIGN AGENCY:
Opto Design
CLIENT:
Strategy & Business Magazine

2 **DESIGN DIRECTOR:**
Kevin Fisher
ILLUSTRATOR:
Philippe Weisbecker
CLIENT:
Audubon Magazine

3 **ART DIRECTOR:**
Giovanni Demauro
ILLUSTRATOR:
Shout
CLIENT:
Internazionale

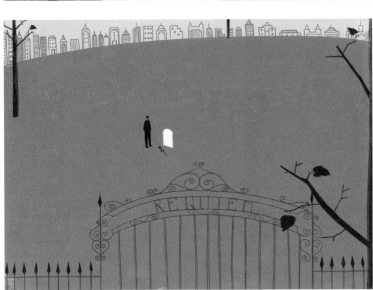

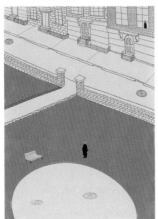

1 **ART VDIRECTOR**:
Jason Treat
ILLUSTRATOR:
Istvan Banyai
CLIENT:
The Atlantic Monthl[

2 **ILLUSTRATOR**:
Valeria Petrone
CLIENT:
Los Angeles Times

1

2

1

2

3

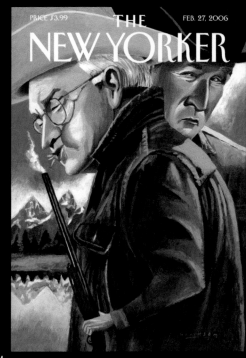

4

1 **ART DIRECTOR:**
Jo-Anne Martin Grier
ILLUSTRATOR:
Chris Pyle
DESIGN AGENCY:
Martini Design
CLIENT:
Todays Parents

2 **ART DIRECTOR:**
Tricia Bateman
ILLUSTRATOR:
Gordon Wiebe
CLIENT:
HOW Magazine

3 **PICTURE EDITOR:**
Paul Davis
ILLUSTRATOR:
Jeffrey Fisher
CLIENT:
The Drawbridge

4 **ART DIRECTOR:**
Françoise Mouly
ILLUSTRATOR:
Mark Ulriksen
CLIENT:
The New Yorker

5 **ART DIRECTOR:**
Stephanie Green
ILLUSTRATOR:
Robert Neubecker
CLIENT:
Cornell University

1 ART DIRECTOR:
Ronn Campisi
ILLUSTRATOR:
Adam McCauley
DESIGN AGENCY:
Ronn Campisi Design
CLIENT:
Harvard Law Bulletin

2 ART DIRECTOR:
Richard Murray
ILLUSTRATOR:
Caroline Tomlinson
DESIGN AGENCY:
Redwood Group
CLIENT:
Royal Mail

3 ART DIRECTOR:
Sarah Habershon
ILLUSTRATOR:
Michelle Thompson
CLIENT:
The Guardian

2

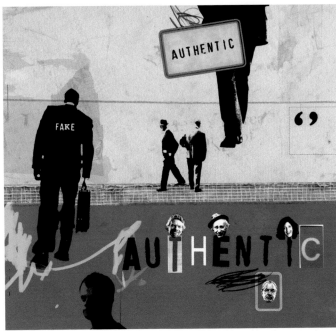

3

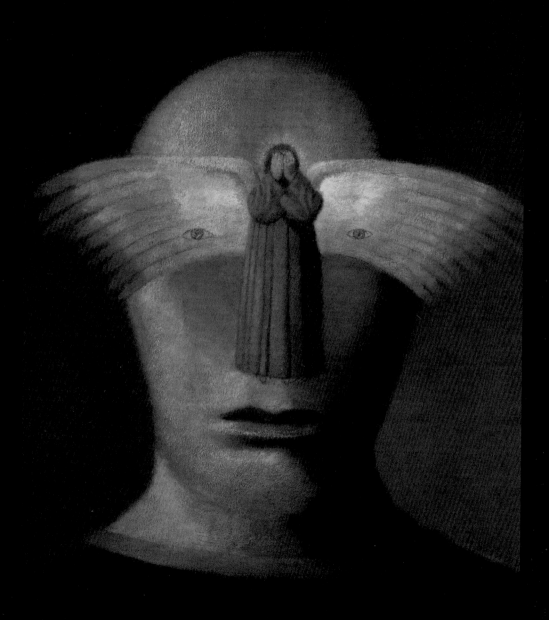

1

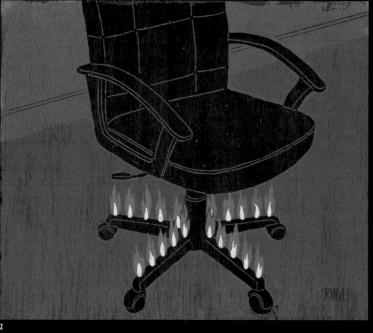

ILLUSTRATOR:
Ken Orvidas
DESIGN AGENCY:
Curtco Publishing
CLIENT:
Worth Magazine

3 **ART DIRECTOR**:
Saskia Burghard
ILLUSTRATOR:
Jens Bonnke
CLIENT:
Energie Spektrum

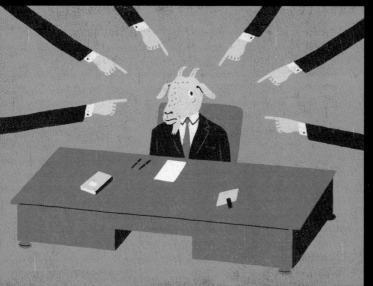

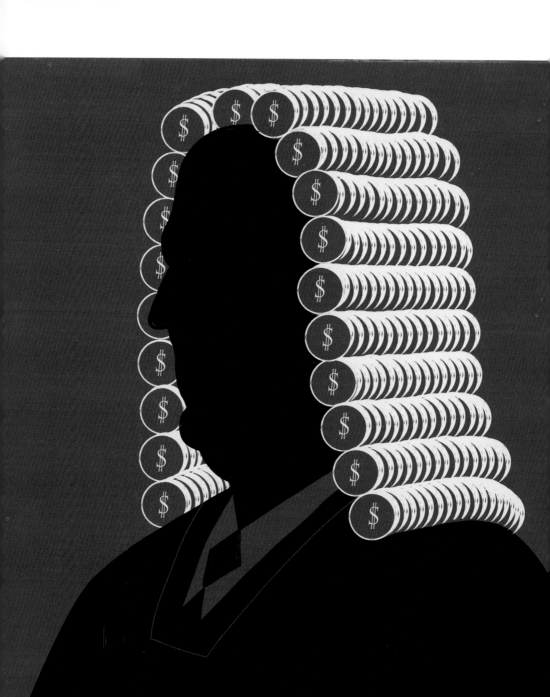

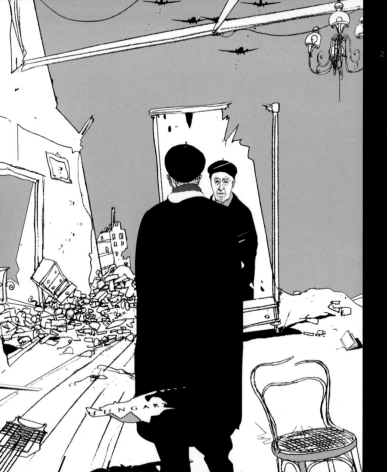

CLIENT:
West, The Los Angeles
Times Magazine

2 ART DIRECTOR:
Christine Curry
ILLUSTRATOR:
Istvan Banyai
CLIENT:
The New Yorker

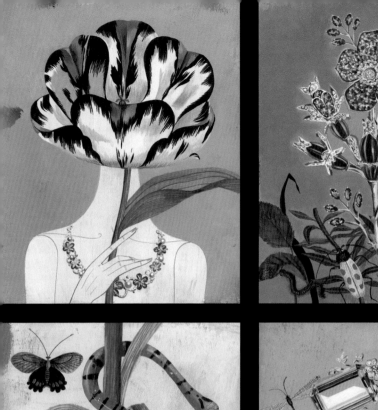
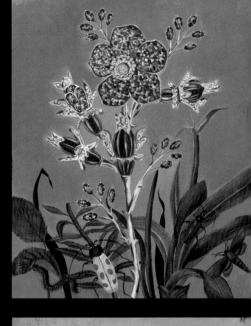

1 ART DIRECTOR:
Konstantin V.
Rolhenburg
ILLUSTRATOR:
Olaf Hajek
CLIENT:
Quest Magazine

2 ART DIRECTOR:
Jose Reyes
ILLUSTRATOR:
Marcos Chin
CLIENT:
Paste

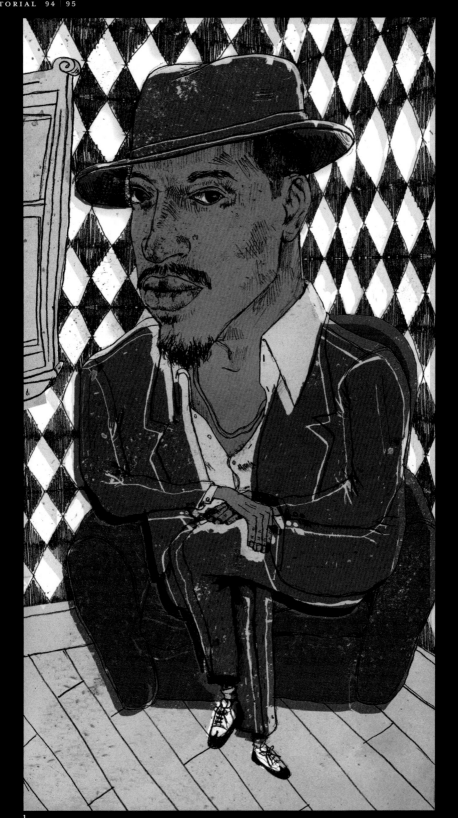

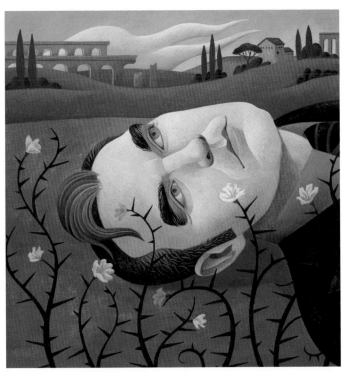

1 ART DIRECTORS:
Hakan Dedeoglu,
Aylin Gungor
DESIGNER:
Umit Kurt
ILLUSTRATOR:
Okan Arabacioglu
CLIENT:
Bant Magazine

2 ART DIRECTOR:
Devin Pedzwater
ILLUSTRATOR:
Jody Hewgill
CLIENT:
Spin Magazine

3 ART DIRECTOR:
Sue Boylan
ILLUSTRATOR:
Dushan Milic
CLIENT:
Seattle Magazine

2

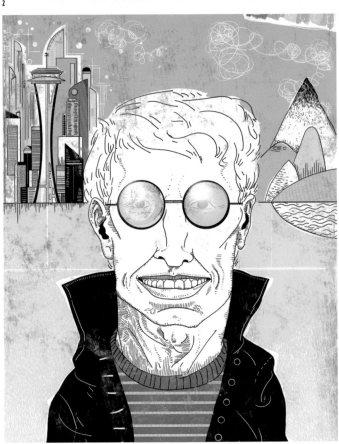

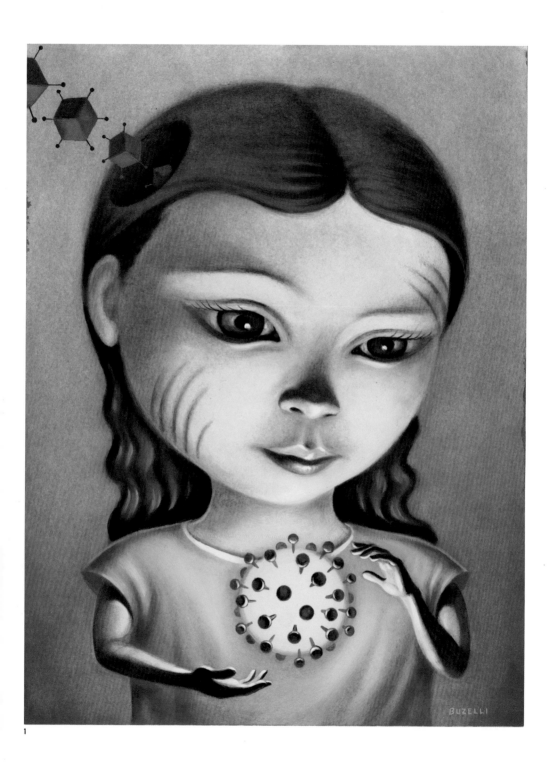

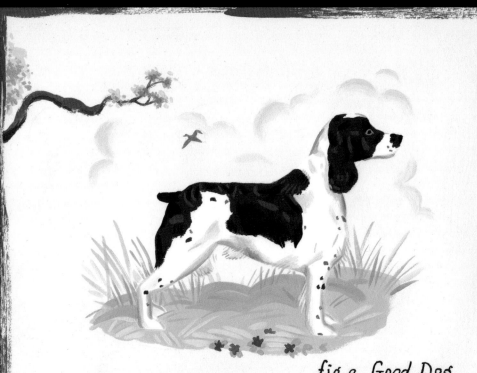

fig a. Good Dog
N. shreddius rosebushis

1 ART DIRECTOR:
Leeann Adams
ILLUSTRATOR:
Penelope Dullaghan
CLIENT:
The Baltimore Sun

2 ART DIRECTOR:
Blake Dinsdale
ILLUSTRATOR:
Chris Buzelli
CLIENT:
Illumination Magazine

3 DESIGNER:
Jeff Glendenning
ILLUSTRATOR:
Marcos Chin
CLIENT:
*The New York Times
Magazine*

2

3

1

2

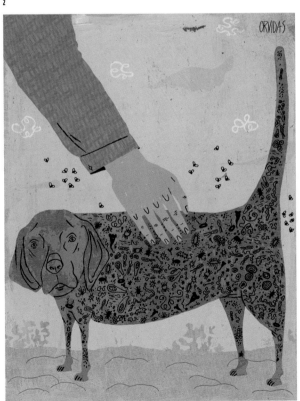

3

1 ART DIRECTOR:
SooJin Buzelli
DESIGNER:
Maynard Kay
ILLUSTRATOR:
Chris Buzelli
CLIENT:
Plan Sponsor Magazine

2 ART DIRECTOR:
Mark Tuchman
ILLUSTRATOR:
Ken Orvidas
DESIGN AGENCY:
Reed Business
CLIENT:
School Library Journal

3 ART DIRECTOR:
Erin Bowen
ILLUSTRATOR:
Ken Orvidas
DESIGN AGENCY:
Pace Communications
CLIENT:
Delta Sky Magazine

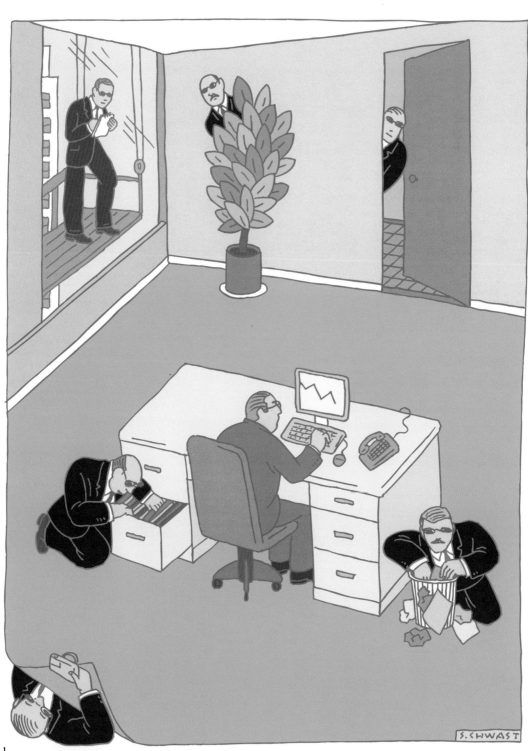

1

2

3

1 ART DIRECTOR:
Christine Curry
ILLUSTRATOR:
Seymour Chwast
CLIENT:
The New Yorker

2 ART DIRECTOR:
Joy O. Miller
ILLUSTRATOR:
John Hendrix
CLIENT:
*Bulletin of the Atomic
Scientists*

3 ART DIRECTOR:
Sam Wright
ILLUSTRATOR:
Jonathan Burton
CLIENT:
*Australian Financial
Review BOSS*

1

2

1 ART DIRECTOR:
Dorothy Yule
ILLUSTRATOR:
Mick Wiggins
CLIENT:
San Francisco Chronicle

2 ART DIRECTOR:
Carol Kaufman
ILLUSTRATOR:
Ward Schumaker
CLIENT:
*Los Angeles Times Book
Review*

3 ART DIRECTOR:
Janet Michaud
ILLUSTRATOR:
Jeffrey Fisher
CLIENT:
Time Magazine

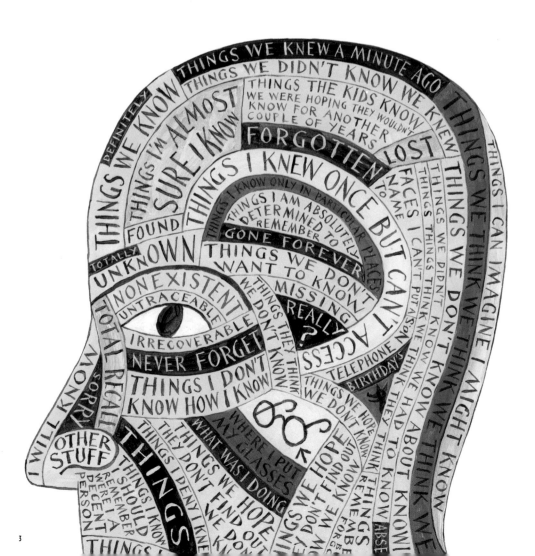

3

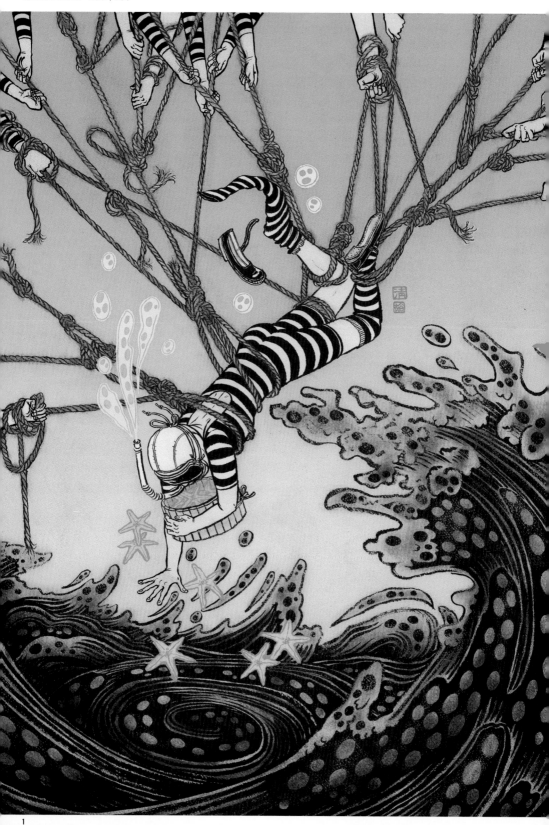

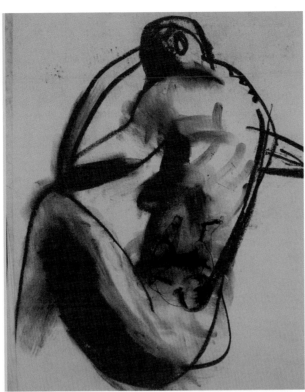

1 ART DIRECTOR:
SooJin Buzelli
DESIGNER:
Maynard Kay
ILLUSTRATOR:
Yuko Shimizu
CLIENT:
Plan Adviser Magazine

2 ART DIRECTOR:
Dorothy Yule
ILLUSTRATOR:
Vivienne Flesher
CLIENT:
San Francisco Chronicle

3 ART DIRECTORS:
Kelly Anne Johnson,
Kelly Martin
ILLUSTRATOR:
Jon Krause
CLIENT:
Government Executive

2

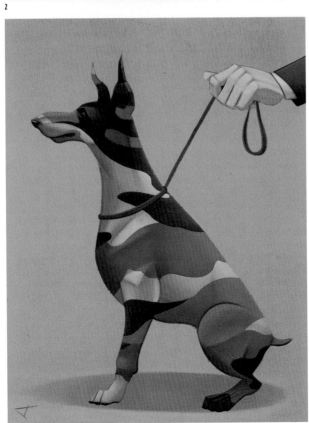

3

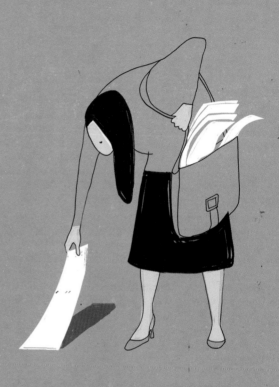

ART DIRECTOR:
Steven Heller
ILLUSTRATOR:
Shout
CLIENT:
*The New York Times
Book Review*

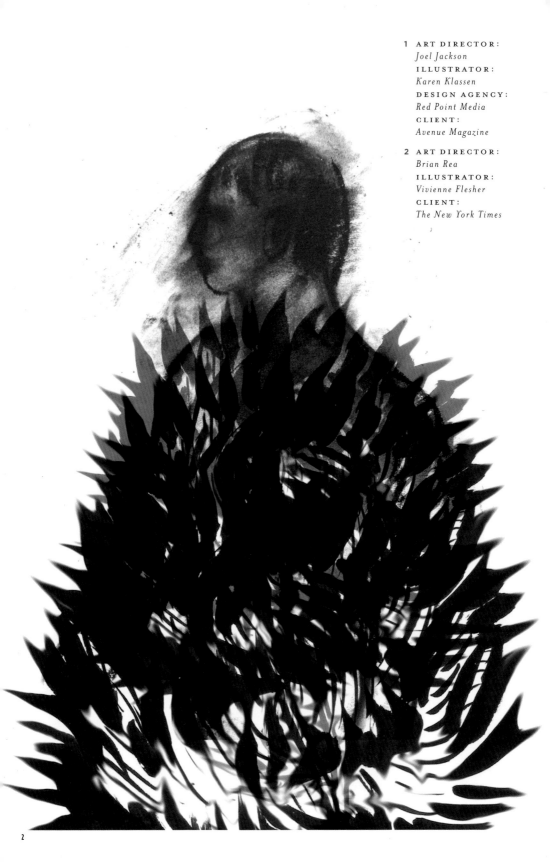

1 ART DIRECTOR:
Joel Jackson
ILLUSTRATOR:
Karen Klassen
DESIGN AGENCY:
Red Point Media
CLIENT:
Avenue Magazine

2 ART DIRECTOR:
Brian Rea
ILLUSTRATOR:
Vivienne Flesher
CLIENT:
The New York Times

What torture has taught me
is that, fascinating
as I find my own
life, it is a
cloudy prism
through which
to view
Creation
absent
reference
to the
experience
of others,
the wisdom
of community,
the demands
of tradition,
the judgment
of history
and the
invitation
of the
Holy.

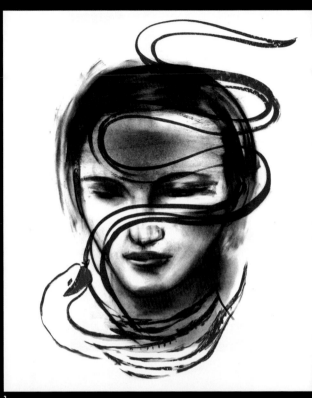

1 **ART DIRECTOR**:
Chris Walton
ILLUSTRATOR:
Brad Holland
CLIENT:
UU World Magazine

2 **ART DIRECTOR**:
Larry Gendron
ILLUSTRATOR:
Vivienne Flesher
CLIENT:
Deal Magazine

3 **ART DIRECTOR**:
Todd Richards
ILLUSTRATOR:
Vivienne Flesher
DESIGN AGENCY:
Cahan & Associates
CLIENT:
See Magazine

2

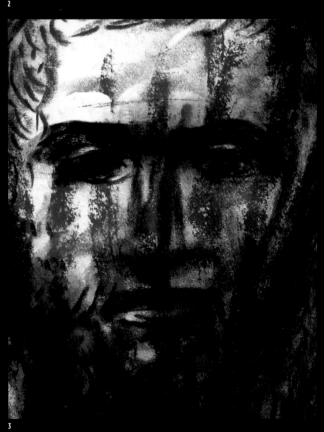

3

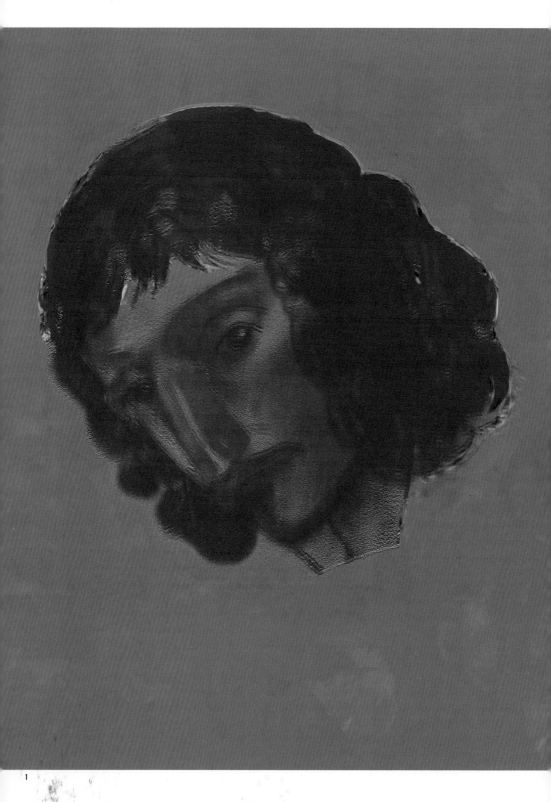

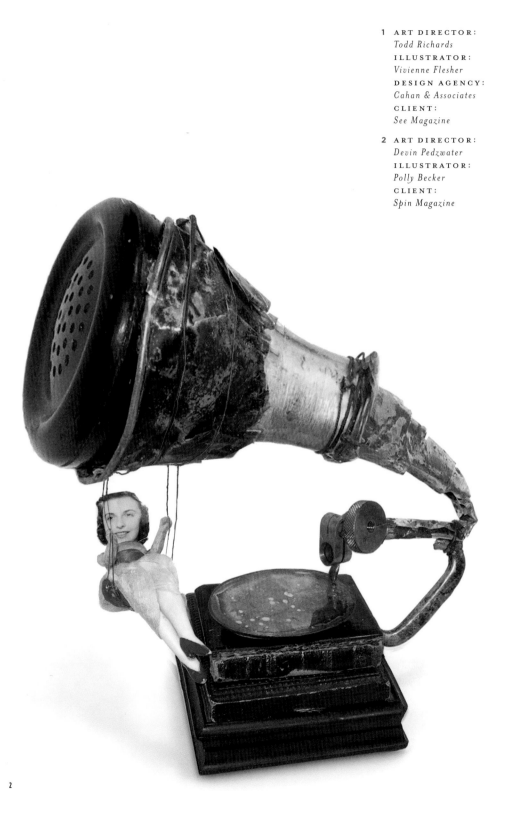

1 ART DIRECTOR:
Todd Richards
ILLUSTRATOR:
Vivienne Flesher
DESIGN AGENCY:
Cahan & Associates
CLIENT:
See Magazine

2 ART DIRECTOR:
Devin Pedzwater
ILLUSTRATOR:
Polly Becker
CLIENT:
Spin Magazine

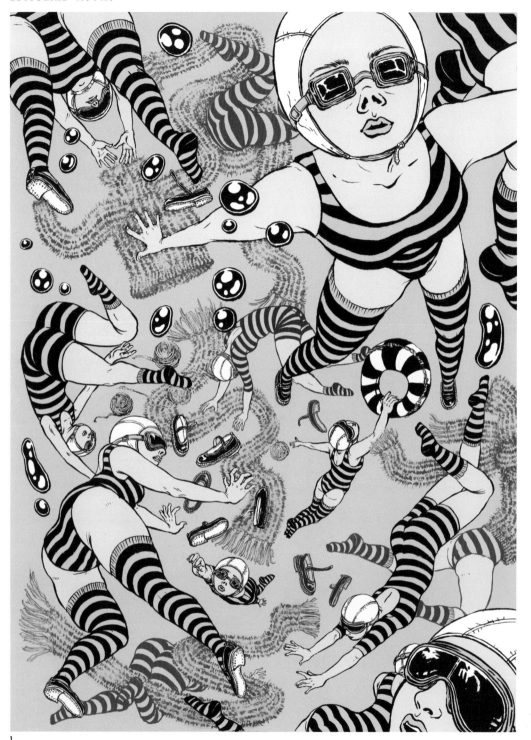

1

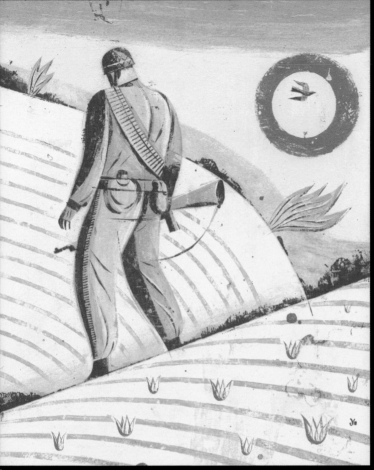

GOLD

1 **CREATIVE DIREC**
 Antonio De Luca
 ILLUSTRATOR
 Yuko Shimizu
 CLIENT
 The Walrus Magazine

 ART DIRECTOR
 Jose Reyes
 ILLUSTRATOR
 Brad Yeo
 DESIGN AGENCY
 Metaleap Design
 CLIENT
 Paste

 ART DIRECTOR
 Lisa Lewis
 ILLUSTRATOR
 Jody Hewgill
 CLIENT
 Los Angeles Magazine

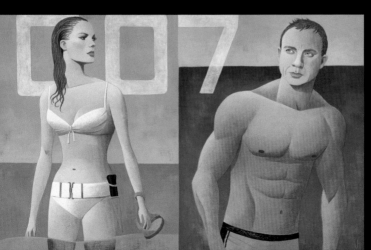

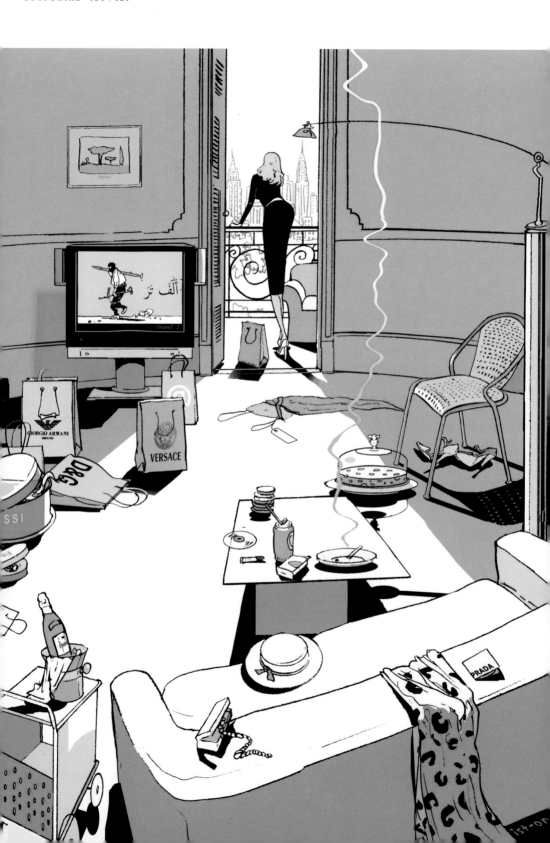

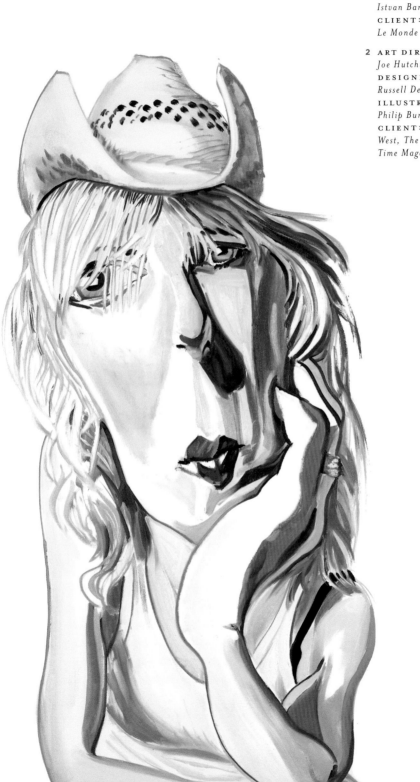

1 ART DIRECTOR:
Fabrizio Sclavi
ILLUSTRATOR:
Istvan Banyai
CLIENT:
Le Monde

2 ART DIRECTOR:
Joe Hutchinson
DESIGNER:
Russell Devita
ILLUSTRATOR:
Philip Burke
CLIENT:
*West, The Los Angeles
Time Magazine*

1

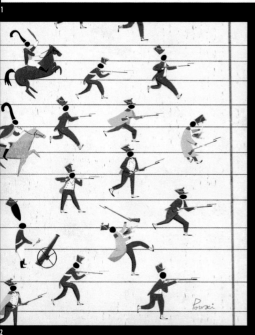

2

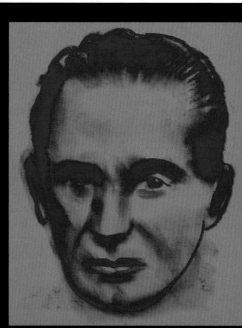

3

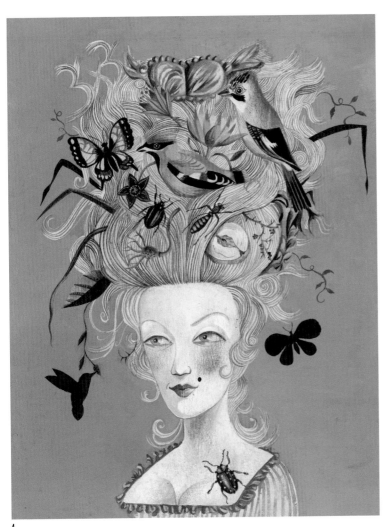

1 ILLUSTRATOR:
Mario Wagner
CLIENT:
PC Magazine

2 ART DIRECTOR:
Ovidio Sutti
ILLUSTRATOR:
Emiliano Ponzi
DESIGN AGENCY:
RCS Media Group

3 ART DIRECTOR:
Todd Richards
ILLUSTRATOR:
Vivienne Flesher
DESIGN AGENCY:
Cahan & Associates
CLIENT:
See Magazine

4 ART DIRECTOR:
Charles Hively
ILLUSTRATOR:
Olaf Hajek
CLIENT:
3x3 Magazine

4

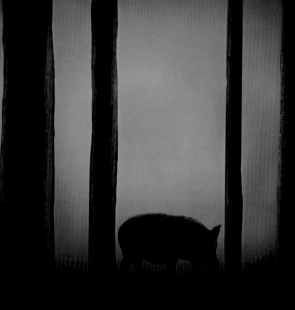

1 ART DIRECTOR:
Arem Duplessis
ILLUSTRATOR:
Matt Murphy
CLIENT:
*The New York Times
Magazine*

2 ART DIRECTOR:
Beth Lower
ILLUSTRATOR:
Eddie Guy
CLIENT:
*Associations Now
Magazine*

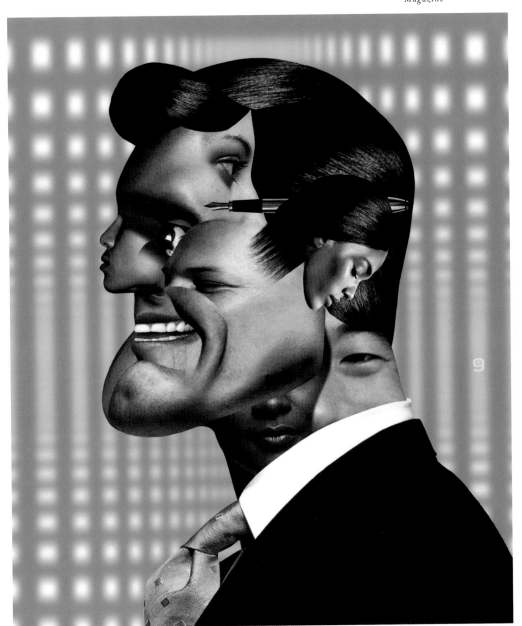

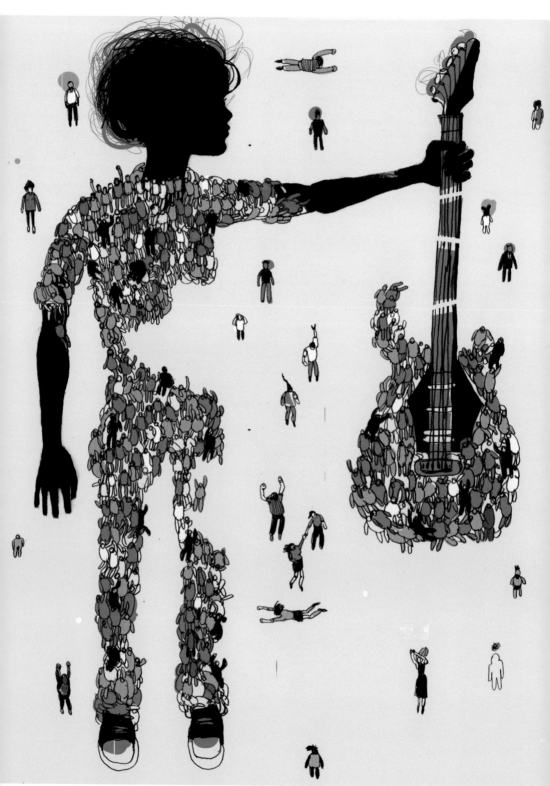

1

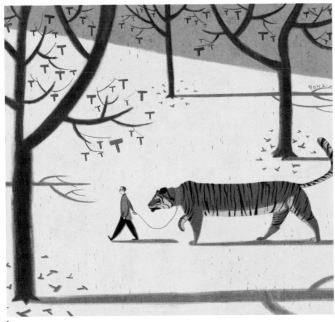

1 ART DIRECTOR:
Jeremy LaCroix
DESIGNER:
Todd Kurnat
ILLUSTRATOR:
Josh Cochran
CLIENT:
Wired Magazine

2 ART DIRECTOR:
Kelly Kingman
ILLUSTRATOR:
Emiliano Ponzi
CLIENT:
The Week

3 ART DIRECTOR:
Greg Klee
ILLUSTRATOR:
Shout
CLIENT:
The Boston Globe

2

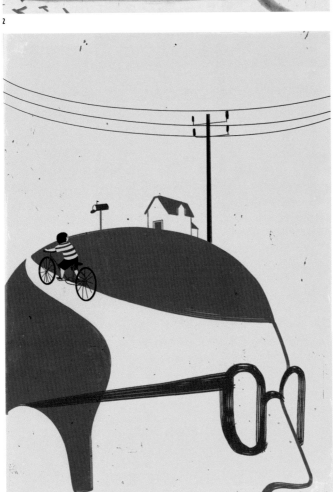

3

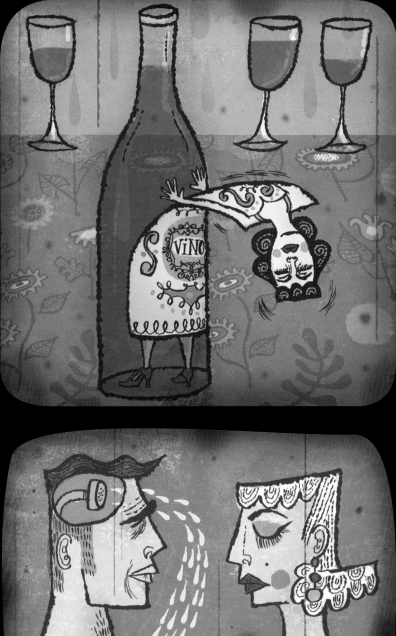
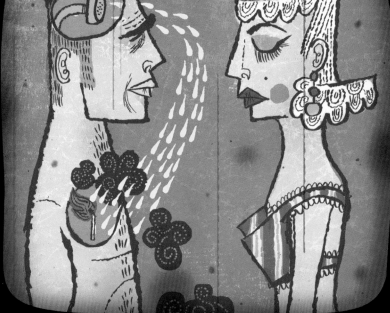

1 ART DIRECTOR:
Lisa Sergi
ILLUSTRATOR:
Gilbert Ford
CLIENT:
Brown Magazine

2 ART DIRECTOR:
Michi Toki
ILLUSTRATOR:
Gilbert Ford
DESIGN AGENCY:
Toki Design
CLIENT:
California Magazine

3 ART DIRECTOR:
Crystal Madrilejos
ILLUSTRATOR:
Andrew Zbihlyj
CLIENT:
Rides Magazine

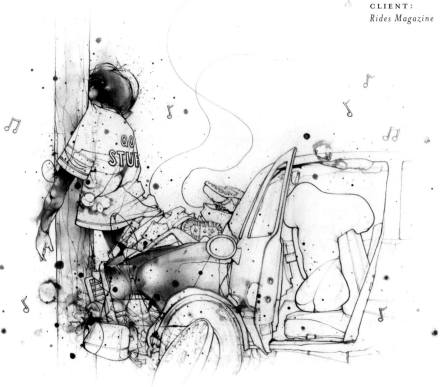

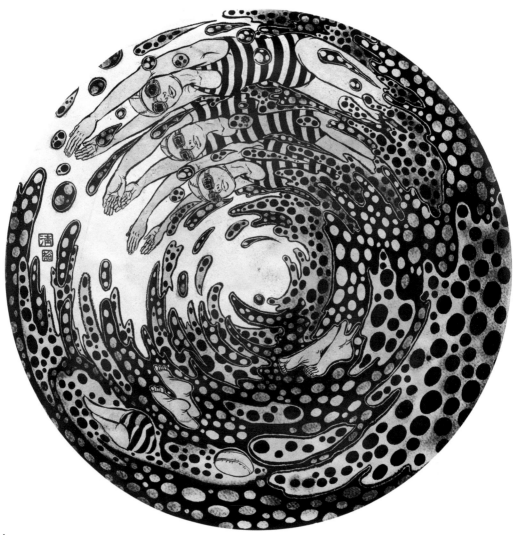

1

2 ART DIRECTOR:
Mike Diehl
ILLUSTRATOR:
Olaf Hajek
DESIGN AGENCY:
Mike Diehl Design
CLIENT:
Warner Bros.

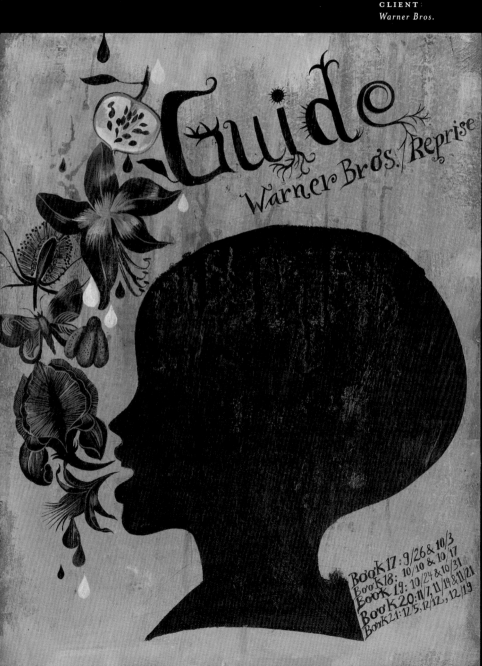

1 **ART DIRECTOR**
Sara Tyson
ILLUSTRATOR
Sara Tyson
CLIENT
Festival of the Sou

2 **ART DIRECTOR**
Nancy Daniels
ILLUSTRATOR
Don Kilpatrick III
CLIENT
The Orinda Arts C

3 **ART DIRECTOR**
Tyler Young
ILLUSTRATOR
Nate Williams
DESIGN AGENC
Young Nomad
CLIENT
Archiventure

1 ILLUSTRATOR:
Valeria Petrone
CLIENT:
Guerra No/Emergency

2 ART DIRECTOR:
Maria Cunningham
ILLUSTRATOR:
Beegee Tolpa
CLIENT:
Scholastic

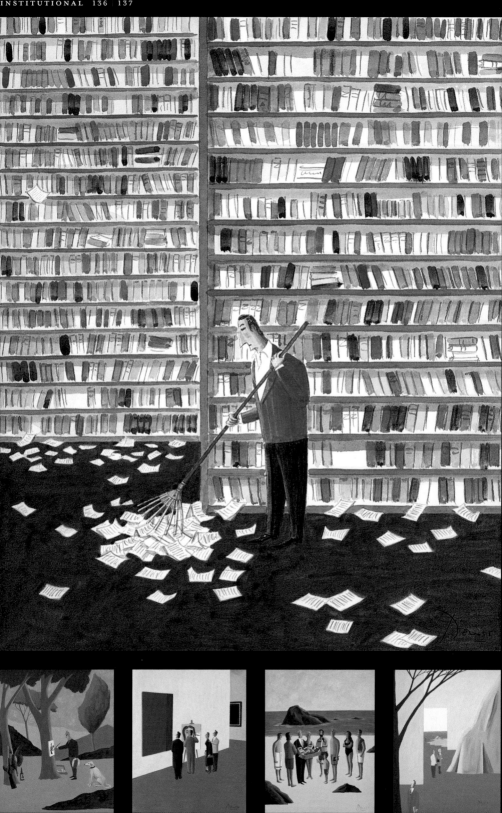

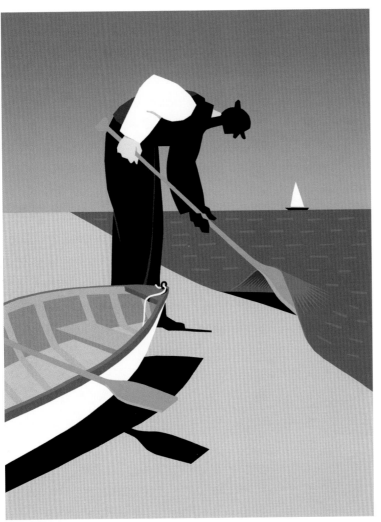

1 EDITOR:
Christina Burns
DESIGNER:
Allison Stern
ILLUSTRATOR:
Benoît
CLIENT:
teNeues Publishing Group

2 CREATIVE DIRECTOR:
Audrey Hane
DESIGNER:
Nancy Paynter
ILLUSTRATOR:
Craig Frazier
DESIGN AGENCY:
HaneChow Inc.
CLIENT:
Exelixis Inc.

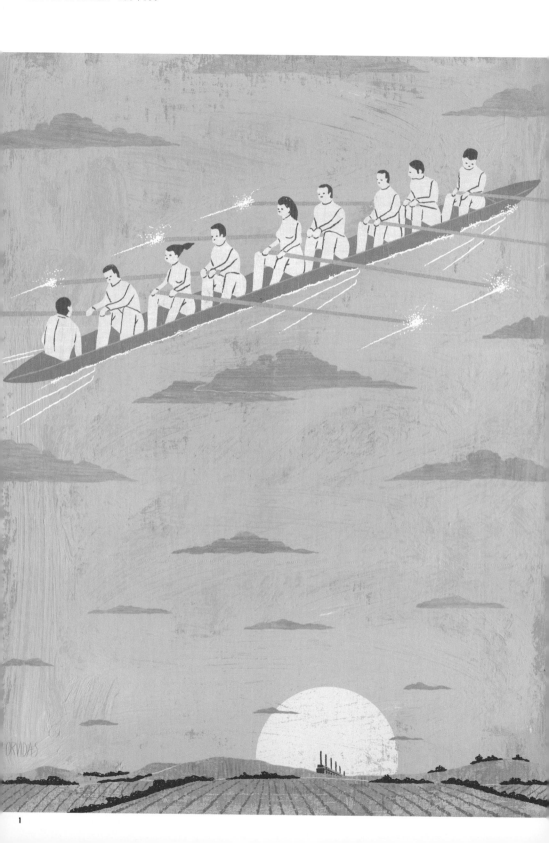

1 ART DIRECTOR:
Dave Betts
ILLUSTRATOR:
Ken Orvidas
DESIGN AGENCY:
*Phinney Bischoff Design
House*
CLIENT:
Zymo Genetics

2-3 ILLUSTRATOR:
Valeria Petrone
CLIENT:
Andersen

2

3

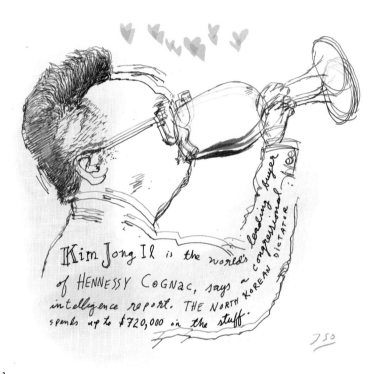

2

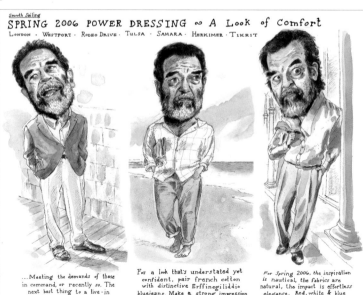

3

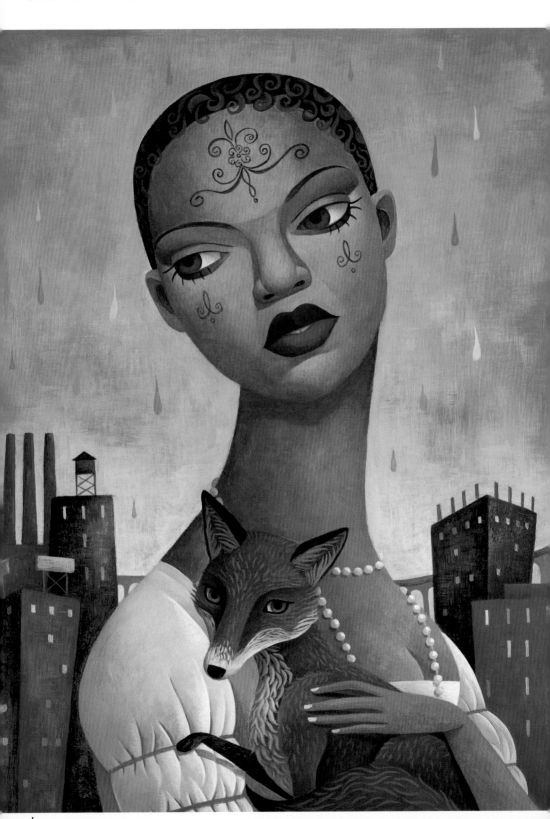

Optimism

Yosh iTo

HALF FULL

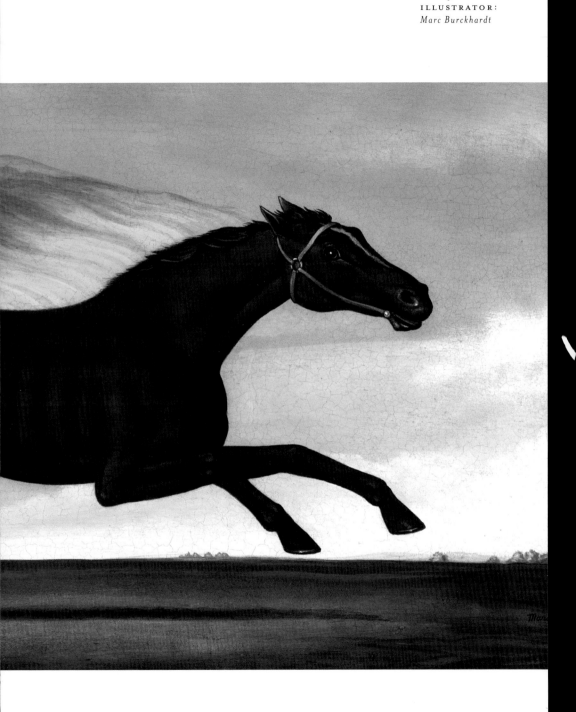

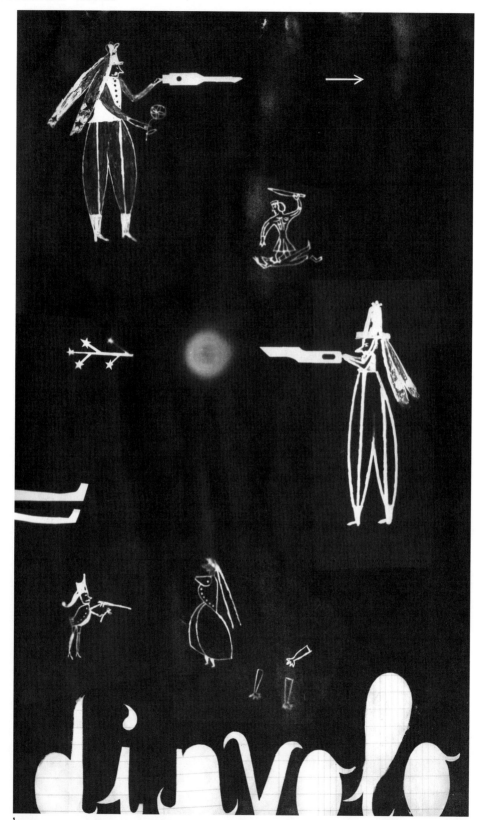

1

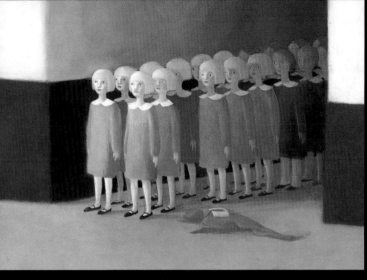

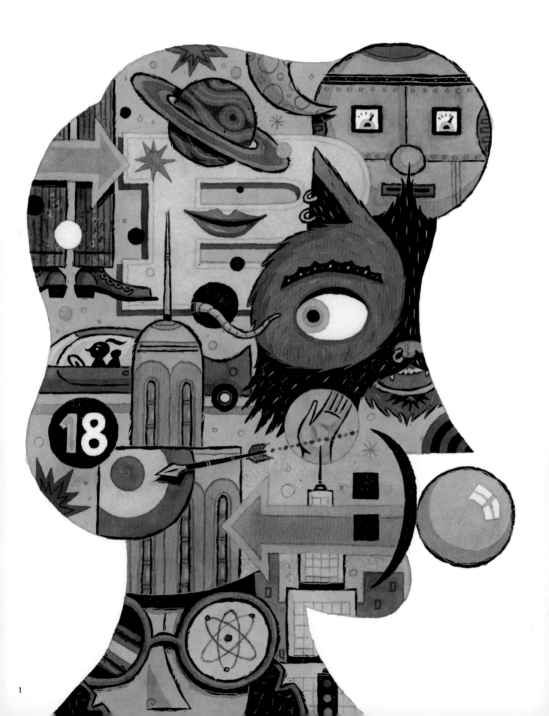

1

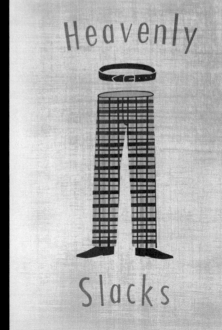

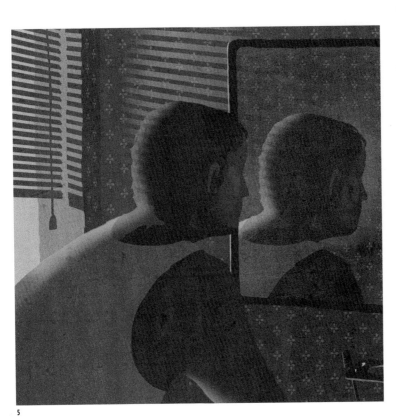

5

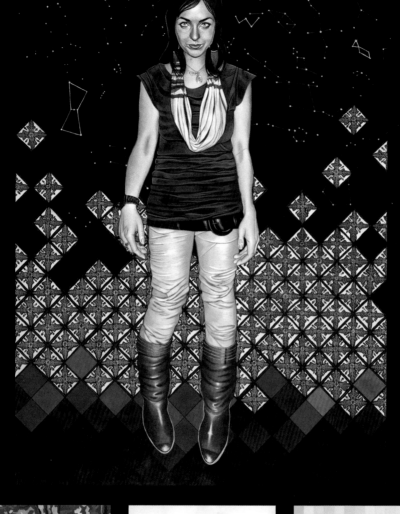

1 **TITLE:**
Kylie Series
ILLUSTRATOR:
Caitlin Kuhwald

2 **TITLE:**
Summer Still Life
ILLUSTRATOR:
Nancy Davis

3 **TITLE:**
The Decline of Canadian Patriotism
ILLUSTRATOR:
Luc Melanson

2

3

TITLE:
*Overlooked New York
Series*
ILLUSTRATOR:
Zina Saunders

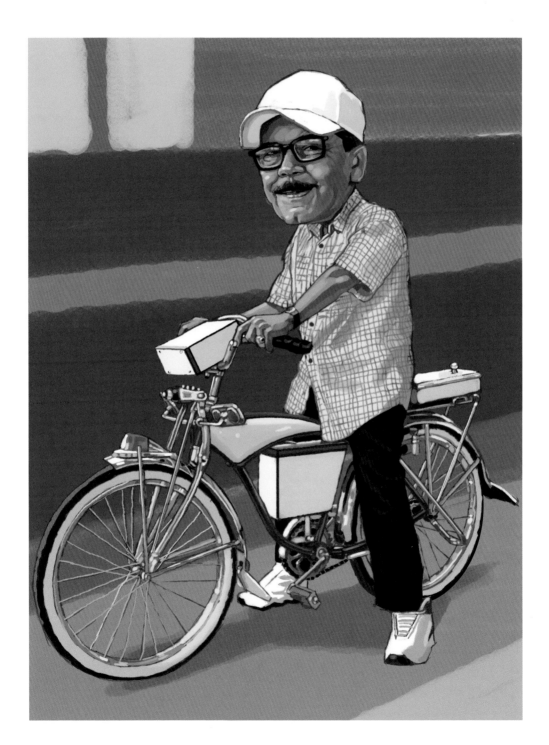

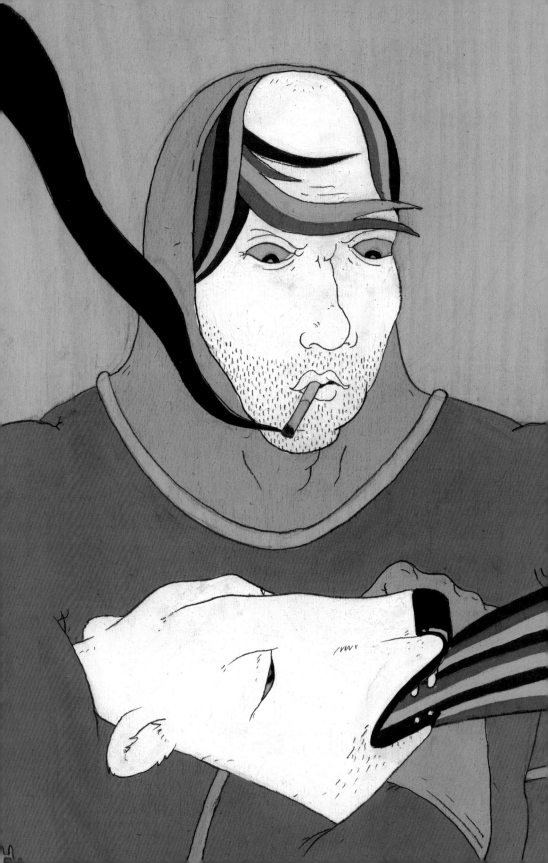

Man 1, Beast 0
ILLUSTRATOR:
Mark Hoffmann

2 TITLE:
Wedding
ILLUSTRATOR:
Aaron Meshon

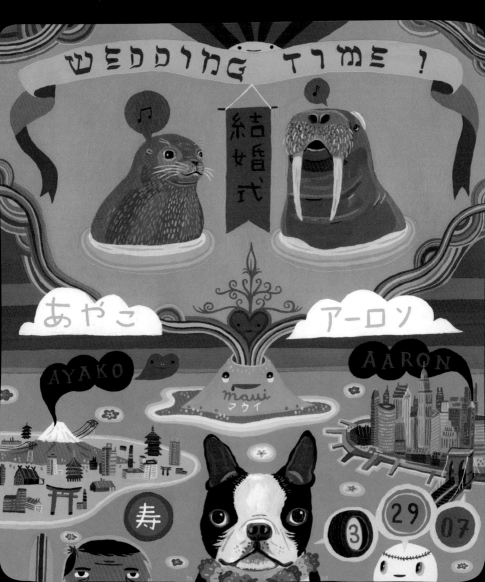

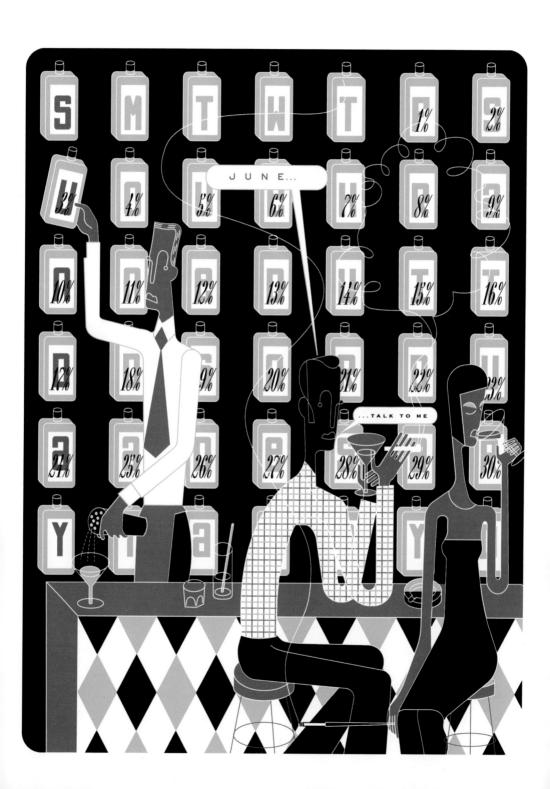

TITLE:
*Self-promotion
Calendar*
ILLUSTRATOR:
Otto Steininger

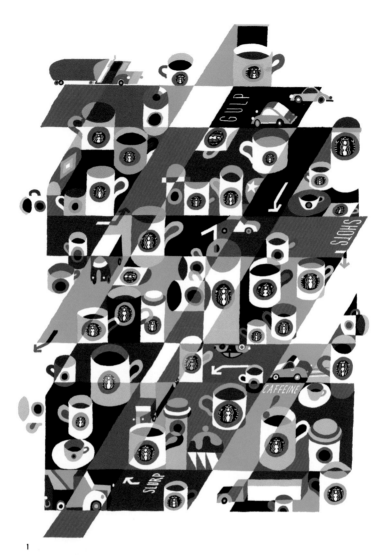

1

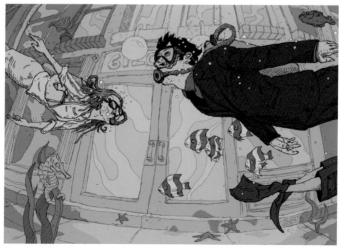

2

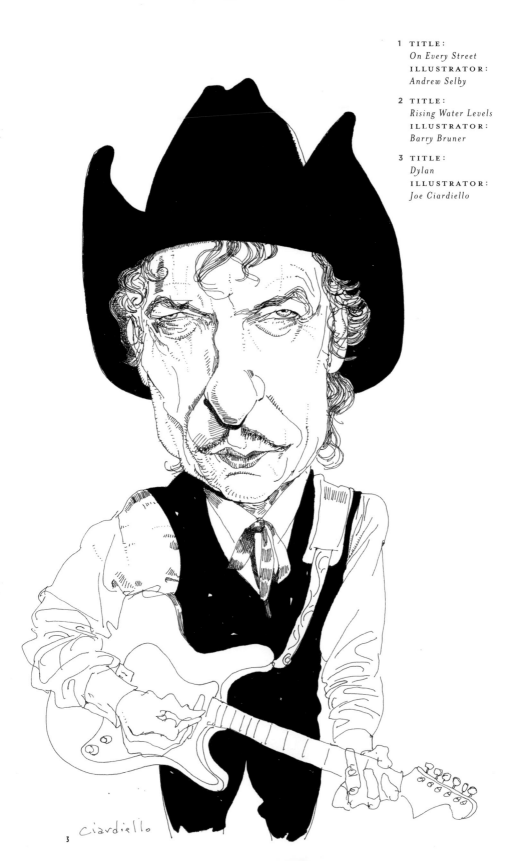

Ciardiello

3

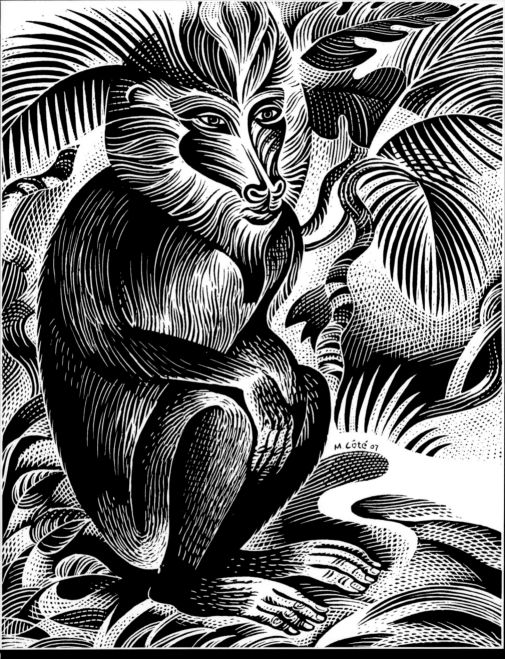

2

3

4

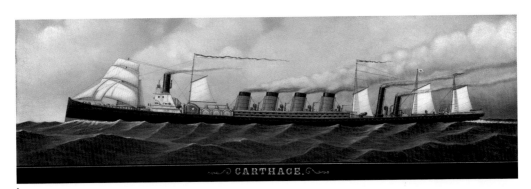

2

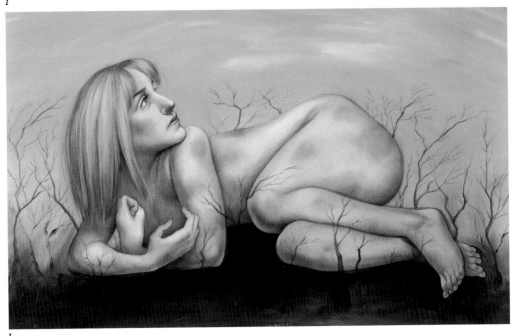

3

...Love is in the air...

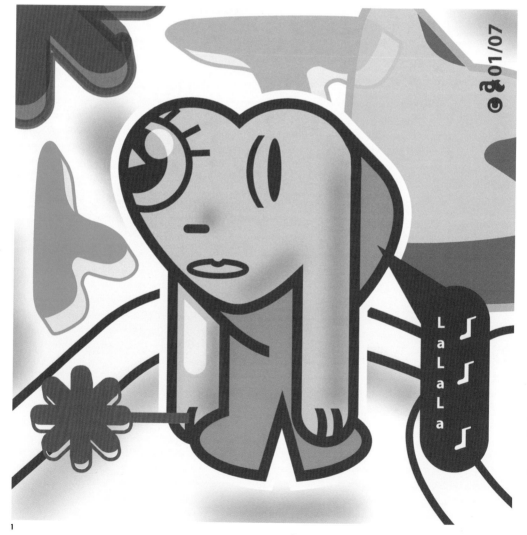

LaLaLa

1

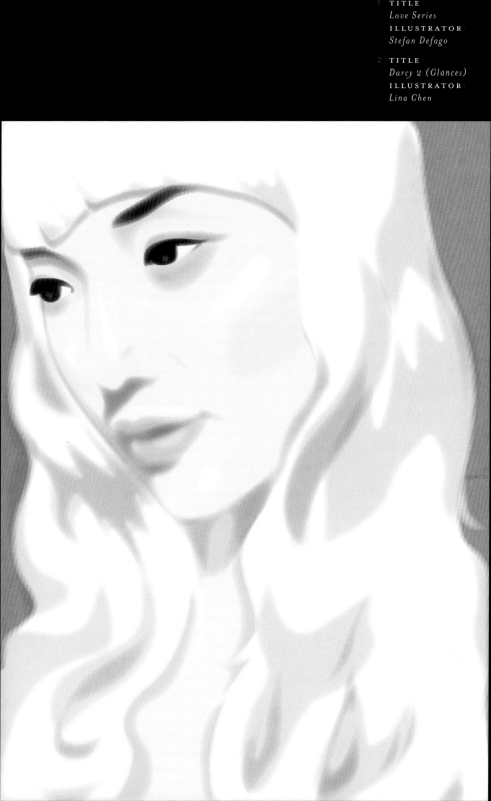

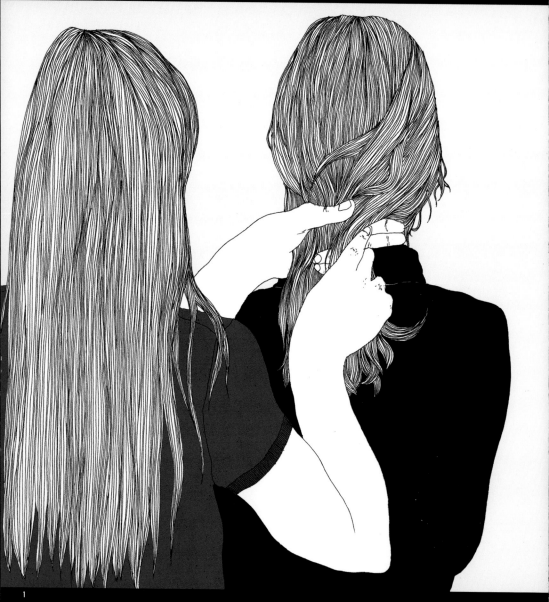

𝕭 is for 𝕭eard

1 TITLE:
Untitled
ILLUSTRATO
Ellen Van Enge

2 TITLE:
B is for...Series
ILLUSTRATO
Lisa Wilkens

𝕭 is for 𝕭oxer

𝕭 is for 𝕭elly

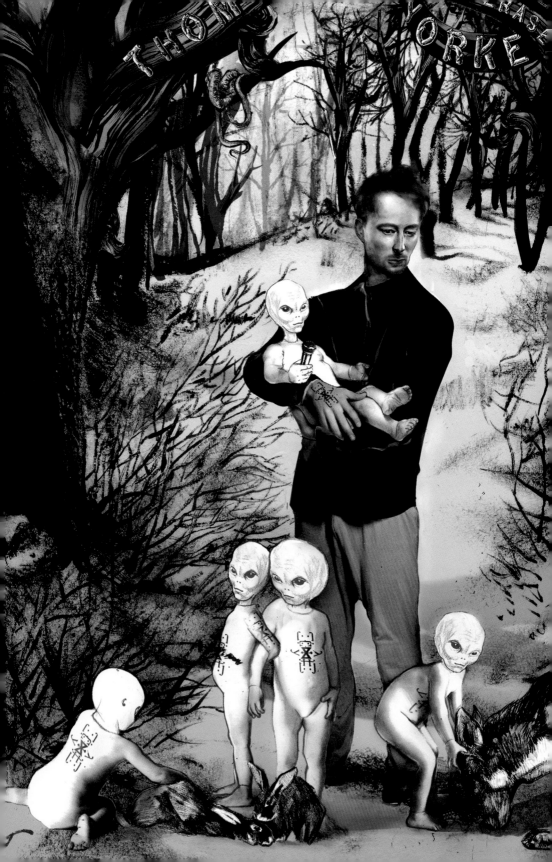

1 TITLE:
Thom Yorke
ILLUSTRATOR:
Steven Tabbutt

2 TITLE:
Central Park
ILLUSTRATOR:
Dan-ah Kim

3 TITLE:
Lily
ILLUSTRATOR:
Marc Burckhardt

2

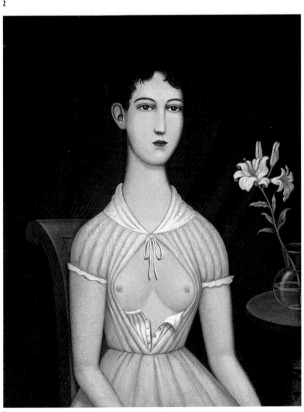

3

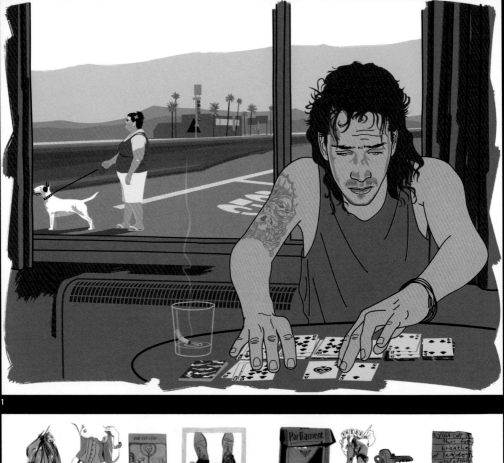

1

2

1

2

1 **TITLE**:
Buzzkill
ILLUSTRATOR:
Mateo

2 **TITLE**:
Robot Icons
ILLUSTRATOR:
Christian Gralingen

1

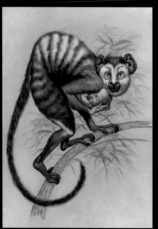
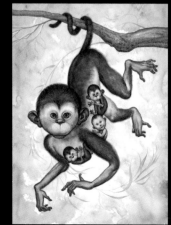
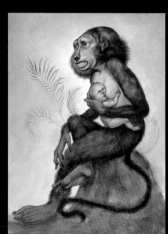

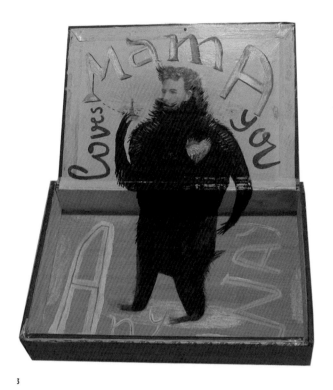

3

4

1 **TITLE:**
Vestigial Virgin
ILLUSTRATOR:
Anita Kunz

2 **TITLE:**
*Unnatural Selection
Series*
ILLUSTRATOR:
Anita Kunz

3 **TITLE:**
*Don't Worry—Momma
Loves You Anyway*
ILLUSTRATOR:
Monika Aichele

4 **TITLE:**
Fanny
ILLUSTRATOR:
Poul Hans Lange

1

2

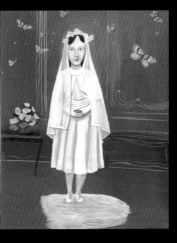

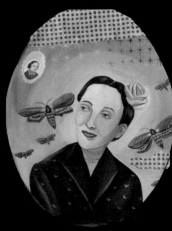

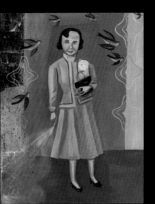

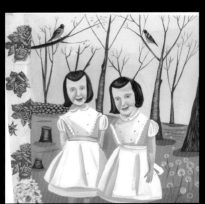

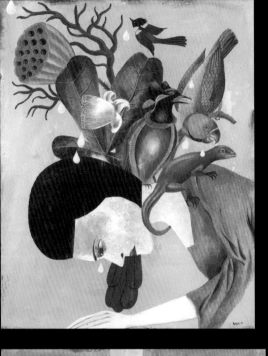
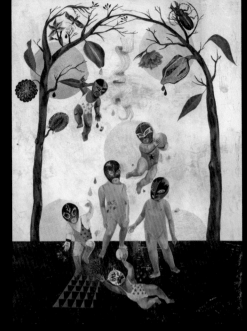
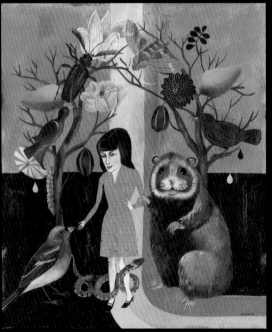
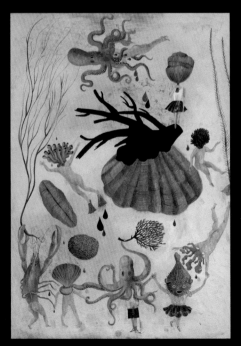

1

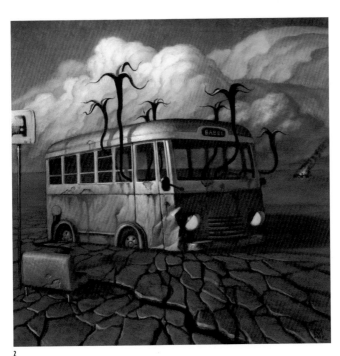

1 TITLE:
Burden
ILLUSTRATOR:
Olaf Hajek

2 TITLE:
The Western Express
ILLUSTRATOR:
Martin Wittfooth

3 TITLE:
Edward's Brain
ILLUSTRATOR:
Jeffrey Fisher

2

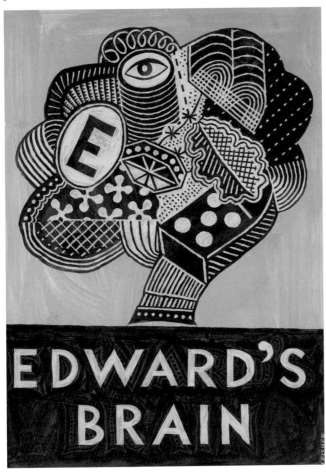

3

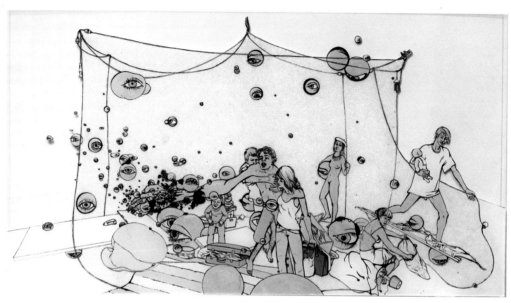

1

TITLE:
Tobacciana Series
ILLUSTRATOR:
Sara Ogilvie

TITLE:
Under the Rainbow
ILLUSTRATOR:
Gordon Wiebe

ANIMATION
SHOW

Gold
198

Silver
199

Bronze
198

View all winners at
www.3x3mag.com/
animationshow.html

1

2

3

4

GOLD

1 ILLUSTRATOR:
Samuel Casal
PUPPETEERS:
Cia. Stromboli
ANIMATOR:
Birdo Studio
WRITERS:
Guilherme Marcondes,
Andrezza Valetin
SOUND DESIGN:
Paulo Beto
MUSIC:
Zeroum
PRODUCER:
Guilherme Marcondes
CLIENT:
Cultura Inglesa Festival

BRONZE

2 ILLUSTRATOR:
4stroke
CREATIVE DIRECTOR:
Tony Cleave
ANIMATOR:
Derek Gebhart,
Davor Celar, Sai Do,
Matthew LaJoie
PRODUCER:
Erin Kuttner

SILVER

3 ILLUSTRATORS:
Courtney Booker,
Aaron Sorenson
CREATIVE DIRECTOR:
Aaron Sorenson
ART DIRECTOR:
Courtney Booker
ANIMATOR:
Aaron Sorenson
PRODUCER:
Jan Johnson
PRODUCTION
COMPANY:
Laika House
CLIENT:
They Might Be Giants

4 ILLUSTRATOR:
4stroke
CREATIVE DIRECTOR:
Tony Cleave
ANIMATOR:
Matthew LaJoie
PRODUCER:
Erin Kuttner

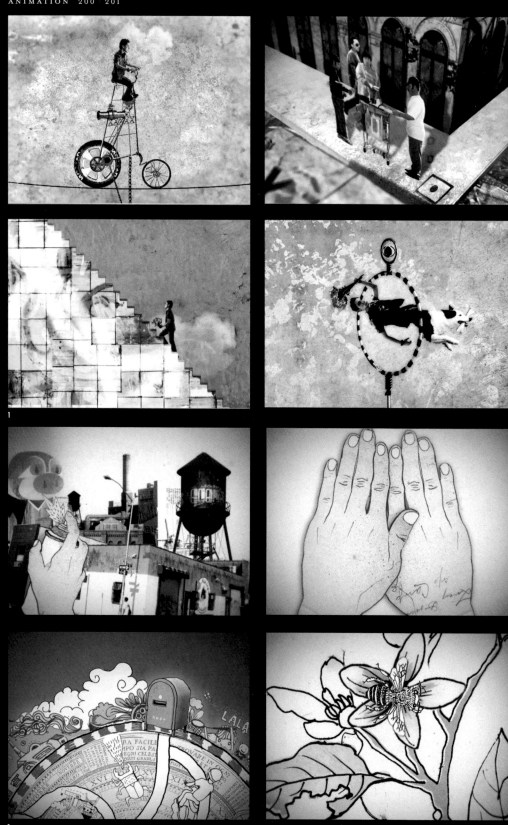

1

2

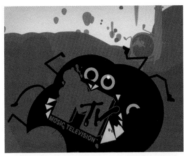

3

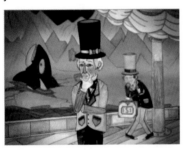

4

1 ILLUSTRATOR:
Richard Borge
CREATIVE DIRECTOR:
Richard Borge
ANIMATOR:
Richard Borge
EXECUTIVE
PRODUCERS:
Randi Wilens,
Mark Medernach
LINE PRODUCER:
Tatiana Rudzinski
PRODUCTION
COMPANY:
RW Media, Duck Studios
CLIENT:
Concord Records, Ozomatli

2 ILLUSTRATOR:
Keng-Ming Liu
ANIMATOR:
Keng-Ming Liu
PRODUCER:
Keng-Ming Liu
PRODUCTION
COMPANY:
MrBighead.net

3 ILLUSTRATOR:
Fons Schiedon
CREATIVE DIRECTOR:
Fons Schiedon
ANIMATOR:
Fons Schiedon
WRITER:
Fons Schiedon
SOUND DESIGN:
Bram Meindersma
PRODUCTION
COMPANY:
FonzTeeVee
CLIENT:
MTV Asia

4 ILLUSTRATOR:
Evan Harris
CREATIVE DIRECTOR:
Aaron Sorenson
ART DIRECTOR:
Jenny Kincade
ANIMATOR:
Wendy Fuller
WRITER:
Eric Terchila
PRODUCER:
Jan Johnson
PRODUCTION
COMPANY:
Laika House
AGENCY:
BPN Inc.
CLIENT:
Oregon Lottery

1 CREATIVE DIRECTOR:
Chel White,
Sebastian Wilhelm
ART DIRECTOR:
Maxi Anselmo
ANIMATOR:
Jerold Howard,
Jeff Riley
WRITERS:
Pablo Minces,
Chel White
PRODUCERS:
Andres Salmoyraghi,
Ray Di Carlo
PRODUCTION
COMPANY:
Bent
CLIENT:
Lux

2 ILLUSTRATOR:
Sarah Orenstein
ANIMATOR:
Sarah Orenstein
SOUND DESIGN:
Chris Lane
MUSIC:
Ari Picker
PRODUCTION
COMPANY:
Rhode Island School of
Design

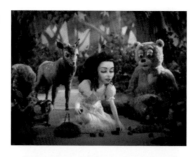

1

2

The Lynx
of Chain

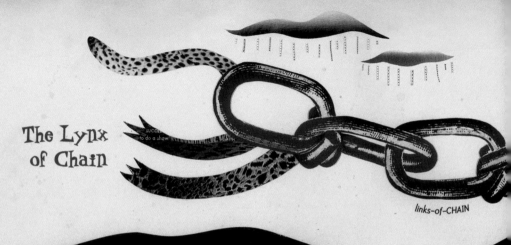

links-of-CHAIN

The sun is up, and on the plain,
We see and hear the LYNX OF CHAIN,
Which, dazzling in the early light,
Is truly a resplendent sight.

As all around the plain it bounds,
It makes resounding clanging sounds,
So as it circumnavigates,
The morning air reverberates.

Carin Berger Design
PUBLISHER:
Greenwillow Books

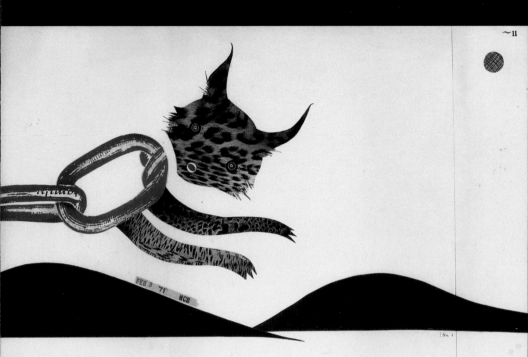

The LYNX OF CHAIN must not forget
To vanish when the weather's wet,
For water soon would make it rust,
Reducing it to orange dust.

It keeps a sharp and watchful eye
On every cloud that happens by.
And that is why the LYNX OF CHAIN
Is never spotted in the rain.

Behold the Bold Umbrellaphant
and Other Poems

BY Jack Prelutsky ILLUSTRATIONS BY Carin Berger

andò dal padrone del Bruno,

per dipingere un cielo. Ma mica tanto, un soffio, un velo..

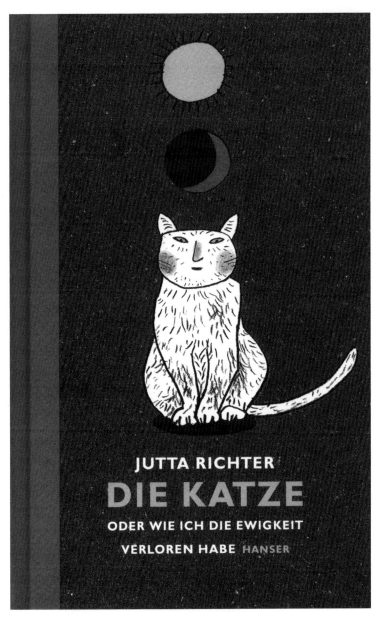

JUTTA RICHTER
DIE KATZE
ODER WIE ICH DIE EWIGKEIT
VERLOREN HABE HANSER

GOLD

1 ILLUSTRATOR:
Valeria Petrone
PUBLISHER:
Emme Edizioni

GOLD

2 ILLUSTRATOR:
Rotraut Susanne Berner
ART DIRECTOR:
Stefanie Schelleis
PUBLISHER:
C. Hanser Verlag

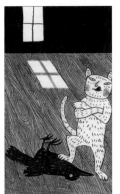
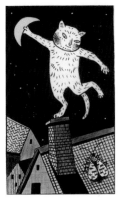
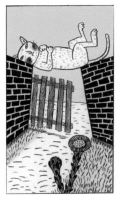

Monday
AИИе Herbauts

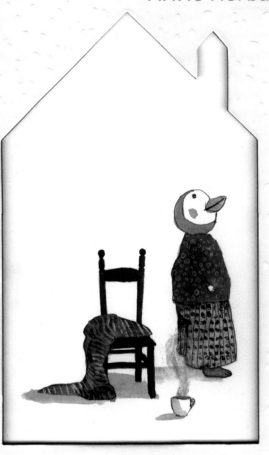

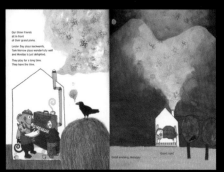

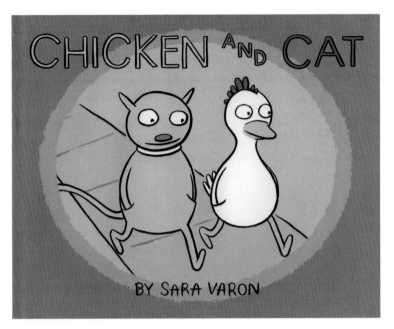

SILVER

1 ILLUSTRATOR:
Anne Herbauts
DESIGNER:
Anne Quévy
DESIGN STUDIO:
Plume Production
PUBLISHER:
Enchanted Lion Books

SILVER

2 ILLUSTRATOR:
Sara Varon
ART DIRECTOR:
David Saylor
PUBLISHER:
Scholastic Inc.

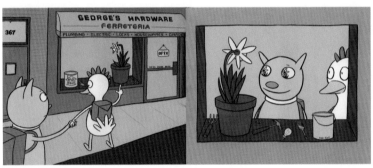

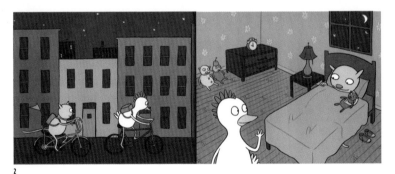

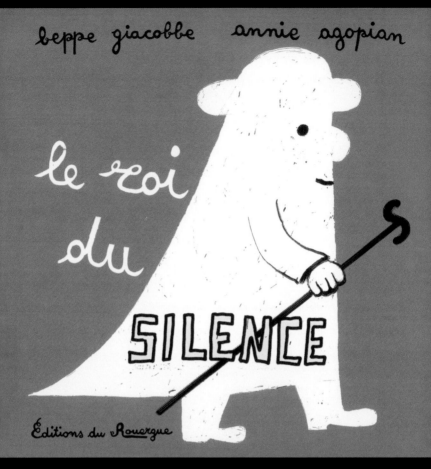

1

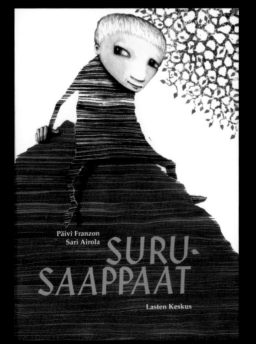

2

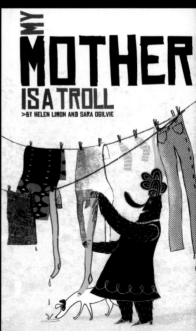

3

Iris van der Heide

ILLUSTRATED BY
Marije Tolman

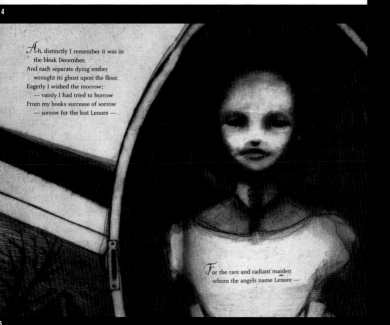

*A*h, distinctly I remember it was in
the bleak December,
And each separate dying ember
wrought its ghost upon the floor.
Eagerly I wished the morrow;
--- vainly I had tried to borrow
From my books surcease of sorrow
— sorrow for the lost Lenore —

*F*or the rare and radiant maiden
whom the angels name Lenore —

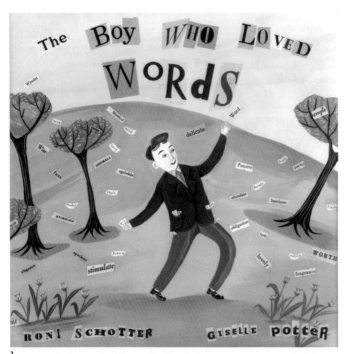

2

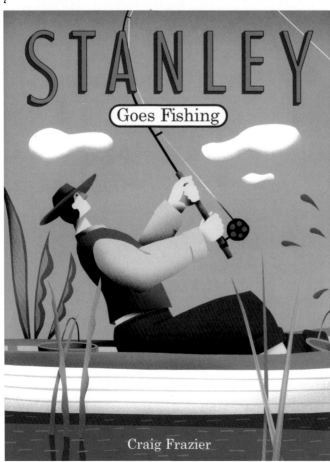

3

1 ILLUSTRATOR:
Jim Burke
ART DIRECTORS:
Andrea Spooner,
Alyssa Morris
PUBLISHER:
Little Brown & Co.

2 ILLUSTRATOR:
Giselle Potter
PUBLISHER:
Random House
Children's Book
IMPRINT:
Schwartz and Wade

3 ILLUSTRATOR:
Craig Frazier
ART DIRECTOR:
Craig Frazier
DESIGN STUDIO:
Craig Frazier Studio
PUBLISHER:
Chronicle Books

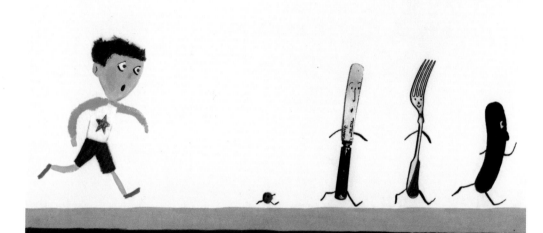

THE RUNAWAY DINNER

Allan Ahlberg • Bruce Ingman

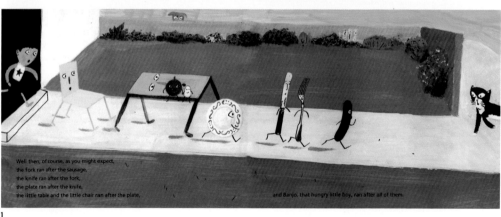

Well then, of course, as you might expect,
the fork ran after the sausage,
the knife ran after the fork,
the plate ran after the knife,
the little table and the little chair ran after the plate,

and Banjo, that hungry little boy, ran after all of them.

1

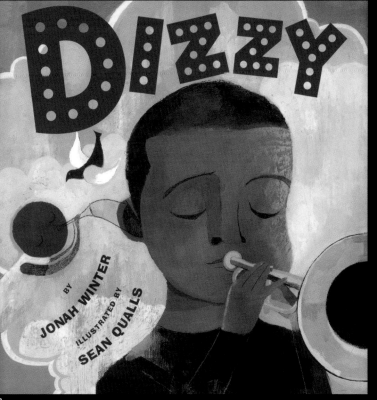

1 **ILLUSTRATOR**:
Bruce Ingman
ART DIRECTOR:
Deidre McDermott
DESIGNER:
Daniel Devlin
PUBLISHER:
Walker Books

2 **ILLUSTRATOR**:
Sean Qualls
ART DIRECTOR:
Marijka Kostin
PUBLISHER:
Scholastic Inc.
IMPRINT:
Arthur A. Levine

3 **ILLUSTRATOR**:
Céline Malépart
ART DIRECTOR:
Diane Primeau
PUBLISHER:
*Dominique et
Compagnie*

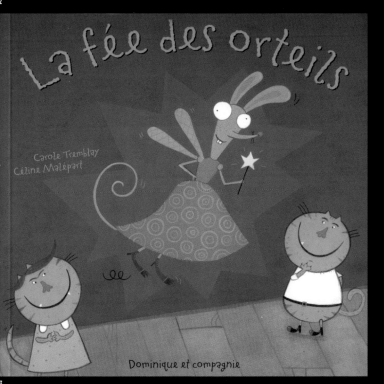

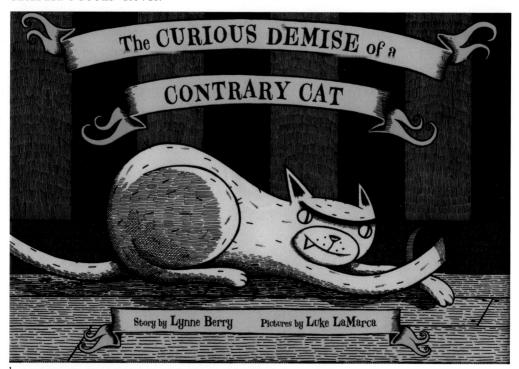

1

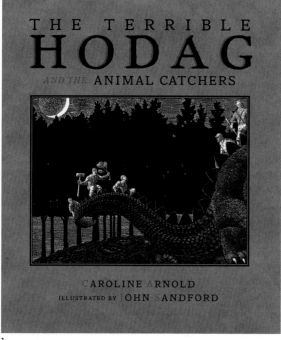

2

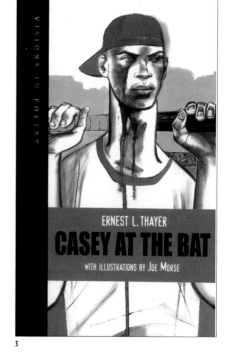

3

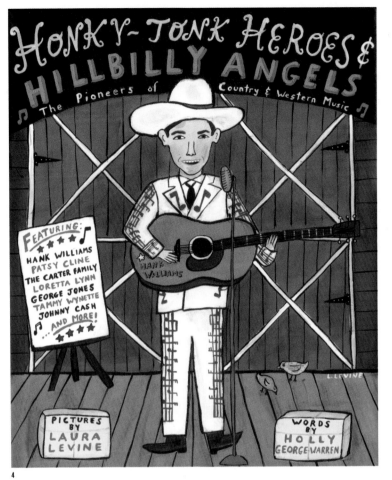

4

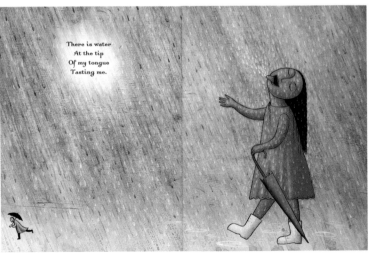

There is water
At the tip
Of my tongue
Tasting me.

5

1 ILLUSTRATOR:
 Luke LaMarca
 ART DIRECTOR:
 Einav Aviram,
 Dan Potash
 PUBLISHER:
 Simon & Schuster Books
 for Young Readers

2 ILLUSTRATOR:
 John Sandford
 ART DIRECTOR:
 Tim Gillner
 PUBLISHER:
 Boyds Mills Press

3 ILLUSTRATOR:
 Joe Morse
 ART DIRECTOR:
 Marie Bartholomew
 DESIGNER:
 Karen Powers
 PUBLISHER:
 Kids Can Press

4 ILLUSTRATOR:
 Laura Levine
 ART DIRECTOR:
 Sheila Smallwood
 DESIGNER:
 Beth Middleworth
 DESIGN STUDIO:
 Bats 4 Bones Design
 Inc.
 PUBLISHER:
 Houghton Mifflin Books

5 ILLUSTRATOR:
 Stefano Vitale
 ART DIRECTOR:
 Martha Rago
 PUBLISHER:
 Harper Collins
 Publishing

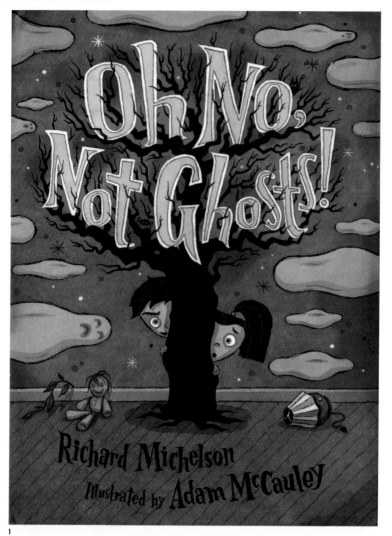

1

2

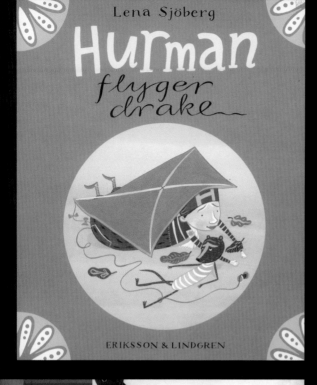

1 ILLUSTRATOR:
 Adam McCauley
 ART DIRECTOR:
 Scott Peale
 DESIGNER:
 Cynthia Wigginton
 DESIGN STUDIO:
 Loop Design
 PUBLISHER:
 Harcourt

2 ILLUSTRATOR:
 Gilbert Ford
 ART DIRECTOR:
 Lorena Siminovich
 PUBLISHER:
 Mudpuppy

3 ILLUSTRATOR:
 Lena Sjöberg
 ART DIRECTOR:
 Lena Sjöberg
 PUBLISHER:
 Eriksson & Lindgren

4 ILLUSTRATOR:
 Carin Berger
 ART DIRECTORS:
 Carin Berger, Tracy
 Johnson
 DESIGN STUDIO:
 Carin Berger Design
 PUBLISHER:
 Chronicle Books

3

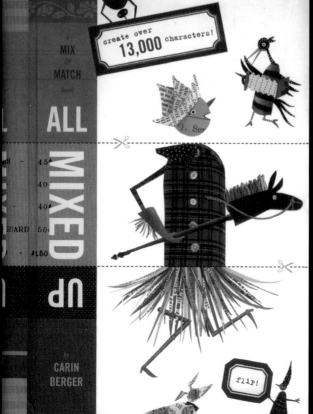

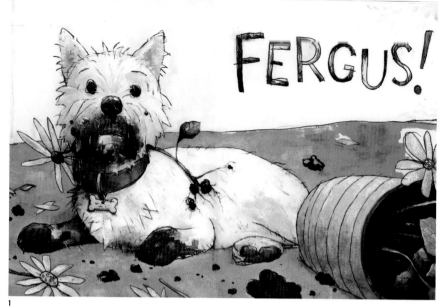

1

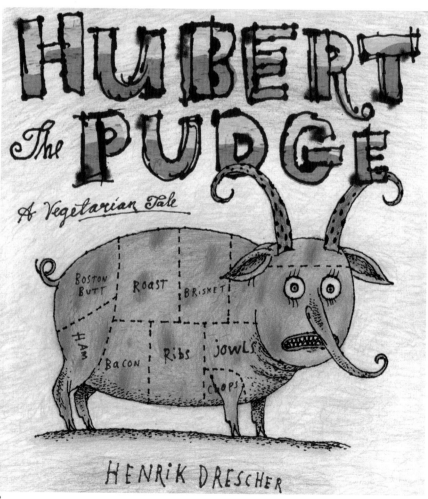

2

The LADDER

1 ILLUSTRATOR:
David Shannon
ART DIRECTORS:
Kathy Westray,
Bonnie Verbur
PUBLISHER:
Scholastic Inc.
IMPRINT:
The Blue Sky

2 ILLUSTRATOR:
Henrik Drescher
ART DIRECTOR:
Chris Paul
DESIGNER:
Scott Magoon
PUBLISHER:
Candlewick Press

3 ILLUSTRATOR:
André da Loba
ART DIRECTOR:
Gémeo Luís
DESIGNER:
Jaquinzinhos
DESIGN STUDIO:
Edições Eterogémeas
PUBLISHER:
Gemeoluis.com

4 ILLUSTRATOR:
Pierre Pratt
ART DIRECTOR:
Chris Paul
DESIGNER:
Scott Magoon
PUBLISHER:
Candlewick Press

MANUELA BARROS FERREIRA, TEXTO | ANDRÉ CARVALHO, ILUSTRAÇÃO | ER. APRESENTAÇÃO

3

4

UTSHAYO MDE

TALL ENOUGH

story by Mhlobo Jadezweni

Illustrations by Hannah Morris

MORE THAN **101** PALINDROMES HIDDEN INSIDE

BY MARK SHULMAN

& ADAM M^cCAULE

MOM
AND
DAD
ARE
PALINDROMES

A DILEMMA FOR WORDS...AND BACKWARD

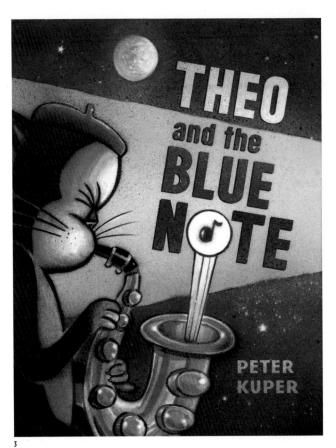

3

4

1 ILLUSTRATOR:
Hannah Morris
DESIGNER:
Hannah Morris
PUBLISHER:
Electric Book Works

2 ILLUSTRATOR:
Adam McCauley
ART DIRECTOR:
Sara Gillingham
DESIGNER:
Cynthia Wigginton
DESIGN STUDIO:
Loop Design
PUBLISHER:
Chronicle Books

3 ILLUSTRATOR:
Peter Kuper
ART DIRECTOR:
Peter Kuper
DESIGNER:
Jim Hoover
PUBLISHER:
Viking

4 ILLUSTRATOR:
Bob Kolar
ART DIRECTOR:
Chris Paul
DESIGNER:
Scott Magoon
PUBLISHER:
Candlewick Press

1 TITLE:
 Let's Have Fun
 ILLUSTRATOR:
 Dubravka Kolanović

2 TITLE:
 Why War Is Never a Good Idea
 ILLUSTRATOR:
 Stefano Vitale

3 TITLE:
 A Garden of Opposites
 ILLUSTRATOR:
 Nancy Davis

RoGue's AlphaBEt

by Michael Kress-Russick

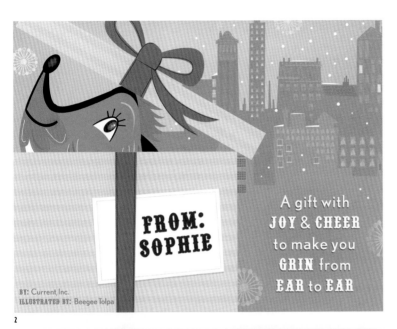

2

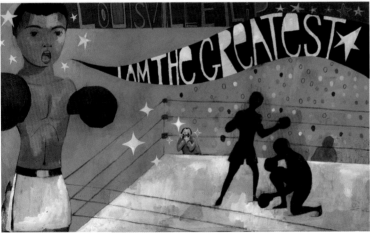

3

TITLE:
Squawking Matilda
ILLUSTRATOR:
Lisa Horstman

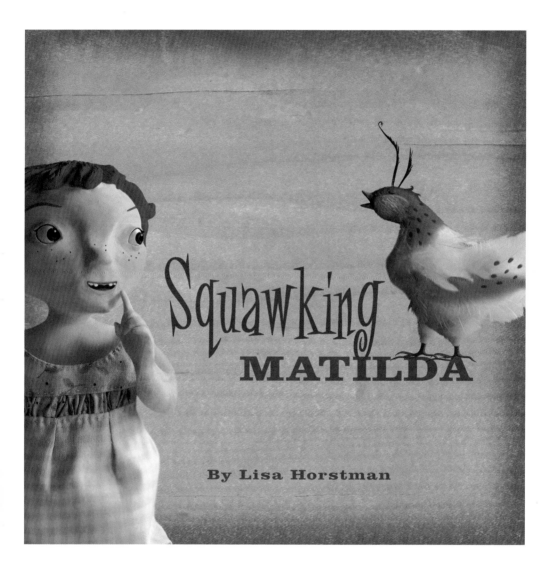

Squawking
MATILDA

By Lisa Horstman

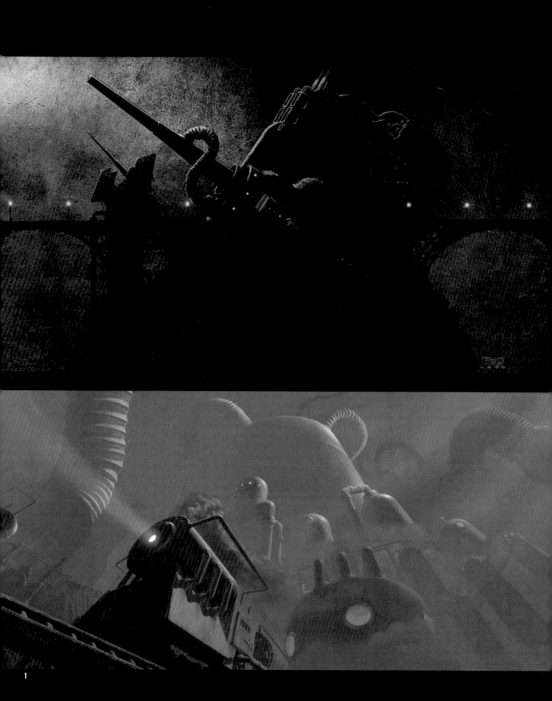

1

2

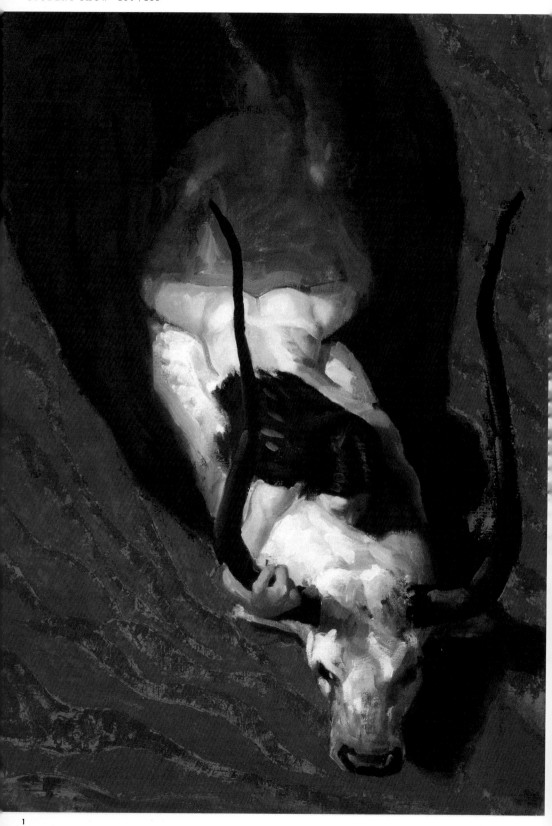

1

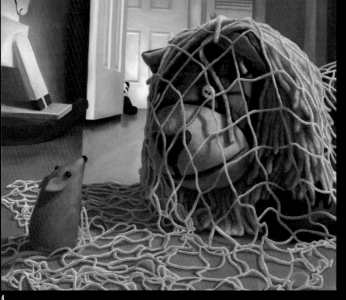

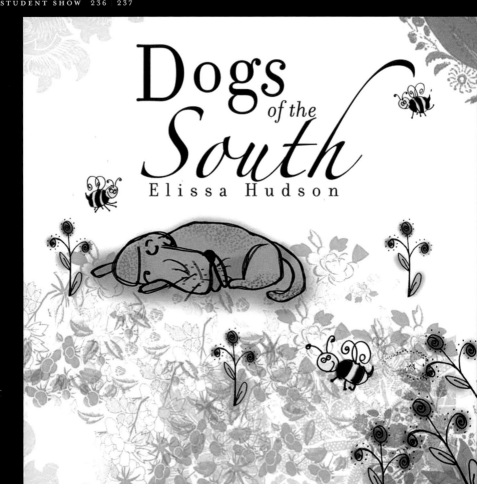

Dogs of the South

Elissa Hudson

1

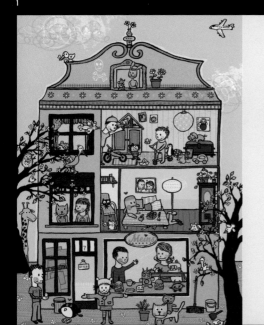

ICH BIN EMMA, UND DAS HIER IST MEIN ZUHAUSE. ES IST DAS HAUS MIT DER NUMMER 7 . IM 2. STOCK SEHT IHR MEINEN KLEINSTEN BRUDER ANTON MIT SEINEM SCHNELLEN UND MEINEN GROSSEN BRUDER PAUL, DER IMMER -ZEICHEN MALT. PAUL MÖCHTE MIT ANTON UND SEINEM DRAUSSEN FAHREN. IM 1. STOCK WARTET ELENA MIT IHRER NEUEN SCHON AUF MICH. WIR WOLLEN MIT PAPA ESSEN! PAPA KRIECHT GERADE UNTER DAS BETT, UM DAS AUFZUHEBEN. MEINE MAMA SITZT AN DER IN IHREM LADEN GANZ UNTEN IN UNSEREM HAUS. SIE NÄHT JEDEN TAG NEUE ZUM KUSCHELN. ASTRID KOMMT OFT ZUM TRINKEN ZU MEINER MAMA. DANN REDEN BEIDE ÜBER DIE VIELEN IM HAUS (FINDEST DU SIE ALLE ?), ÜBER MEINEN LIEBEN ONKEL ALBERT UND DIE ANDEREN VERRÜCKTEN !

ABER ETWAS STIMMT HIER NICHT! FINDE RAUS, WAS ES IST!

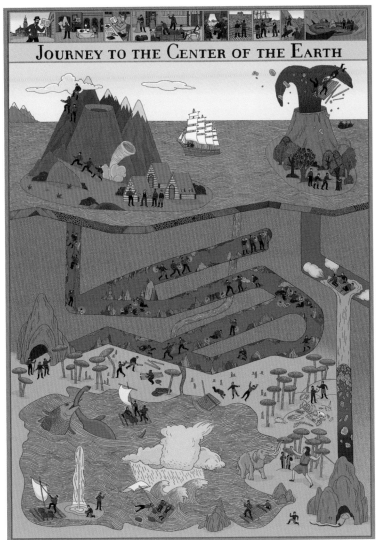

JOURNEY TO THE CENTER OF THE EARTH

3

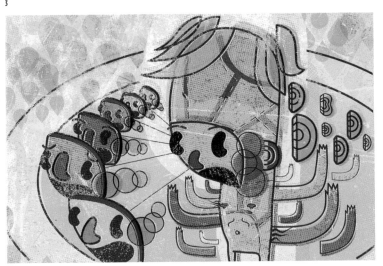

4

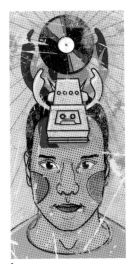

5

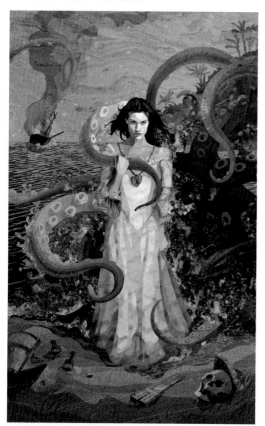

1

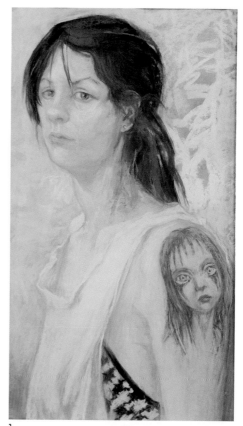

2

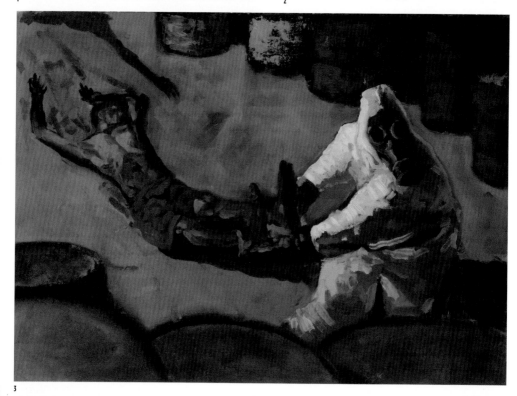

3

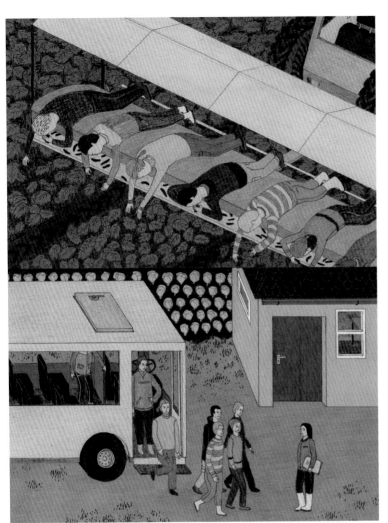

1 *Robert Scott*
INSTRUCTOR:
Doreen Minuto
INSTITUTION:
*Fashion Institute of
Technology*

2 *Beth Peck*
INSTRUCTOR:
Michael Kareken
INSTITUTION:
*Minneapolis College of
Art and Design*

BRONZE
3 *Chris White*
INSTRUCTOR:
Sterling Hundley
INSTITUTION:
*Virginia Commonwealth
University*

SILVER
4 *Sophia Martineck*
INSTRUCTOR:
Henning Wagenbreth
INSTITUTION:
*Universität der Künste,
Berlin*

1

2

3

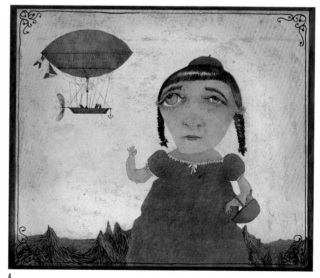

4

5

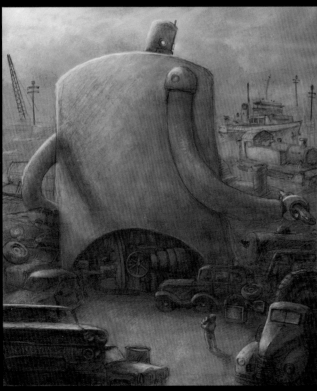

6

1

2

3

4

1

2

3

Clemente Botelho
INSTITUTION
Sheridan Institute

3 Alexei Vella
INSTRUCTOR:
Clemente Botelho
INSTITUTION
Sheridan Institute

1-2 *Anne Costa*
INSTRUCTORS:
Doug Dowd,
John Hendrix
INSTITUTION:
Washington University
in St. Louis

BRONZE
3 *Alexei Vella*
INSTRUCTOR:
Clemente Botelho
INSTITUTION:
Sheridan Institute

4 *Marianne Chevalier*
INSTRUCTOR:
Marie Lessard
INSTITUTION:
Université Laval

3

4

PUBLISHER'S NOTE

*Every effort has been made to ensure that the
credits and contact information comply with
the information provided us. 3x3 is not
responsible for missing information or credits.
We apologize for any omissions or spelling
errors that may have been carried through from
the original submission materials.*

Always rotating.
New illustration talent featured every day.
Never the same place twice.

folioplanet.com

THE ILLUSTRATION ACADEMY

Summer 2008

**Mark English, Natalie Ascencios, John English, Sterling Hundley, Gary Kelley
Anita Kunz, Robert Meganck, C.F. Payne, George Pratt, Barron Storey, Brent Watkinson**

June 2-JULY 18

Lecture Week:
June 23-27

941 955 8869 WWW.ILLUSTRATIONACADEMY.COM

Ringling College of Art and Design I att: **The Illustration Academy** I 2700 North Tamiami Trail I Sarasota I FL 34234